apples

50 TRIED & TRUE RECIPES

Julia Rutland

Adventure Publications
Cambridge, Minnesota

Cover and book design by Lora Westberg
Edited by Emily Beaumont

Cover images: All images by Julia Rutland

All images copyrighted.

All images by Julia Rutland unless otherwise noted.
Africa Studio/shutterstock.com: 6; DGLimages/shutterstock.com:
2-3; Oksana Mizina/shutterstock.com: 62-63; Olga Rasche
/shutterstock.com: 9; Dmytro Sheremeta/shutterstock.com: 4-5

Photos identified by page in alphabetical order using a, b, c, d, e, f
Used under license from Shutterstock.com:
Potapov Alexander: 19b; BWFolsom: 19c; Norman Chan: 18a;
Chiyacat: 17a; Denphumi: 21b; GGPro Photo: 17d; Chad
Hutchinson: 19a; Ivaylolvanov: 18d; Khairulzirwansyah25: 21e;
Kovalena_Ka: 20b; KPG_Payless: 20f; Nikolay Kurzenko: 16c, 17f,
18c, 21c; Lana Langlois: 20d; Lubolvanko: 20a; Ericka J Mitchell:
20c; ncristian: 19e; Dylan OHara: 17e; PIXbankCZ: 19f; Olga
Rasche: 18f; Angel Simon: 21a; StockUp: 16b; Julia Summers: 17c;
topseller: 18e; Denise Torres: 18b; Joao Virissimo: 16a, 19d

These images are licensed under the CC0 1.0 Universal (CC0 1.0)
Public Domain Dedication license, which is available at https:
//creativecommons.org/publicdomain/zero/1.0/: USDA, artist
Royal Charles Steadman: Northern Spy, 20; USDA, artist Deborah
Griscom Passmore: Winesap, 21

Cosmic Crisp® image used courtesy of The Cosmic Crisp® Team: 17;
SugarBee® image used courtesy of Chelan Fresh (www.chelanfresh
.com): 21

10 9 8 7 6 5 4 3 2

Apples: 50 Tried & True Recipes

Published by Adventure Publications
An imprint of AdventureKEEN
310 Garfield Street South
Cambridge, Minnesota 55008
(800) 678-7006
www.adventurepublications.net

ISBN 978-1-59193-907-8 (pbk.); ISBN 978-1-59193-908-5 (ebook)

Acknowledgments

Many thanks to the abundance of family and friends who offered support and willing palates during the tasting portion of creating this book. My husband, Dit, is always there to pick up dinner when I've spent the day elbow deep in pies, pots, and pans. I couldn't do any of it without his quiet and consistent encouragement. To my girls Emily Bishop and Corinne—thanks for always being good sports when mom is into her projects.

Thank you to Brett Ortler, Emily Beaumont, and Lora Westberg at AdventureKEEN for guiding me through this book and others. Cheers to all who celebrate the printed recipe!

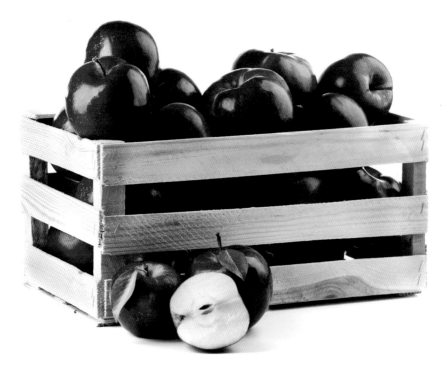

apples

50 TRIED & TRUE RECIPES

Table of Contents

Acknowledgments 6

About Apples. 10

Apple Varieties 16

Jams, Sauces, and Beverages 22

Vanilla Blush Applesauce 25

Slow-Cooker Apple Butter 27

Spiced Apple Jelly Sauce 29

Apple-Cranberry Jam 31

Apple Butter-Bourbon Sauce 33

Hot Mulled Cider 35

Cookies, Breads, and Small Bites 36

Toffee-Apple Oatmeal Cookies 39

Apple Pie Cookie Cups. 41

Nutty Apple Bars 43

Apple Blondies . 45

Apple Baklava . 47

Apple Puff Roses 49

Easy Apple Hand Pies 51

Whole-Grain Apple Muffins 53

Herbed Apple Mini Muffins 55

Apple-Cinnamon Scones 57

Apple-Cinnamon Quick Bread. 59

Apple Cheddar Biscuits 61

Sweets and Desserts 62

Open-faced Apple Pie with
 Salted Pecan Crumble 65

Easy Double Crust Apple Pie. 67

Upside-down Apple-Pecan Pie. 69

Apple Custard Pie. 71

Dutch Apple Crumble Pie. 73

Apple-Cranberry Lattice Pie 75

Mincemeat Pie. 77

Simple Apple Tart 79

Cheese-Apple Danish 81

Apple Spice Cake with
 Butterscotch Drizzle 83

Apple Bundt Cake with Maple Glaze . . . 85

Butterscotch Apple Cupcakes 87

Apple Streusel Cheesecake 89

Baked Apple Clafouti 91

Fruit-Stuffed Apple Dumplings 93

Caramel Apples. 95

Apple Noodle Kugel 97

Almond-Apple Crisp. 99

Sweet Apple Rice Pudding 101

Soups, Salads, and Savories **102**

Roasted Apple-Parsnip Soup. 105

Apple-Cheddar Beer Soup 107

Chicken, Apple, and Napa
 Cabbage Salad. 109

Broccoli-Apple Salad. 111

Apple Tabbouleh Salad 113

Apple Butter Meatballs. 115

Chicken-Apple Breakfast Sausage. 117

Apple Butter Baked Beans 119

Ham-and-Apple Croissant Sandwiches. . . 121

Apple-Sausage-Cheddar Cornbread 123

Marinated Pork Tenderloin with
 Apple Salsa . 125

Apple-Stuffed Pork Loin 127

Smoked Pork Chops and Apple Skillet . . . 129

Index. **130**

About the Author **136**

About Apples

The familiar cracking sound as you bite into a ripe and juicy apple is about as mouthwatering as the fruit's sweet-to-tangy flavor and flowery aroma. It's no wonder the humble apple is America's favorite fruit.

- Apples originated in an area between the Caspian and Black Seas and archaeologists have evidence that humans have consumed apples for thousands of years.

- There are 7,500-plus varieties of apples grown worldwide.

- In the U.S., there are perhaps 2,500 varieties of apples, but only around 100 are grown commercially. The only apple native to North America is the crabapple.

- Americans, per capita, enjoy apples more than any other type of fruit. About two-thirds of the U.S. apple crop is eaten as fresh fruit.

- Washington produces more than half of the apples grown in the U.S. Other top states include New York, Michigan, Pennsylvania, California, and Virginia. About a quarter of harvested apples are exported.

- Apples are the second-most valuable fruit in the U.S., behind oranges. Some of the most popular varieties include Honeycrisp, Gala, Fuji, and Granny Smith. For decades, Red Delicious was the most-consumed apple in the U.S., thanks in part to its toughness and resistance to damage (making shipping easier), but its popularity has waned as newer varieties have been introduced to the market.

- Apple growers can produce new types of apples reasonably quickly by grafting growing tips of a new variety onto existing trees.

- Johnny Appleseed was a real person! Frontier nurseryman John Chapman traveled through the American Midwest in the early 1800s, planting nurseries of apple trees (not just planting apple seeds at random).

- Apple trees require several years (sometimes up to a decade) before producing their first fruit.

- Apple blossoms are usually pink when they first open, fading to white. The blooms appear late in spring, which minimizes frost damage. That means apple trees can grow farther north than many other fruits. One apple tree even survived a winter (albeit in an unheated greenhouse) at 68 degrees north latitude in the Northwest Territories of Canada!

- You can grow an apple tree from an apple seed, but it will not produce the same apple variety (say, Honeycrisp) of the original fruit. That's because apple trees require cross-pollination to produce fruit, so the apple seed is the product of the original apple tree (the Honeycrisp) and the apple tree that provided the necessary cross-pollination.

- Most apples are still harvested by hand in the fall.

- Apples have five seed pockets called carpels. The small spots all over the apple skin (and on other fruits like pears and grapes) are lenticels—small pore-like openings that help a plant breathe. You'll easily see them on potatoes and mangoes too.

- Apples float because around 25 percent of their volume consists of air, making them ideal for "bobbing" in a tub of water.

- Apples ripen 6 to 10 times faster at room temperature than when refrigerated.

- One gallon of apple cider is made from about 36 apples.

- Apples produce their own natural wax to help the fruit retain moisture and firmness. The natural wax is occasionally white and powdery looking but can be buffed until it shines. Some producers spray additional food-grade wax to replace any wax lost to washing because the protective coating makes them easier to store and enhances their shininess.

How to Buy

Look, touch, and smell are the senses you'll need to select the perfect apple.

Look: Inspect the apple for any bruises or nicks in the skin. Except for the yellow and green varieties, such as Golden Delicious and Granny Smith, most apples are fully ripe when most of the fruit is red. Apples won't often be one solid color. Buy the ones most covered in red, or allow them to further ripen before using. Dull apples are typically overripe. Lenticels are the small pores that allow gases to pass between the flesh of the fruit and the skin. They look like speckles. The more lenticels, the sweeter the apple.

Touch: Make sure the apple is firm to the touch with no soft spots. Different varieties are firmer than others, but a soft apple is usually overripe.

Smell: Apples should smell fresh and pleasant; avoid those with fermented or rotten aromas.

Does size matter? Not really, except when it comes to the number/weight you need to purchase, or the effort required to peel them. Organic apples are smaller than their conventional counterparts.

Apple equivalents:

1 pound = about 2 large or 3 medium-size apples

1 pound = 2½ to 3 cups chopped

2 to 2½ pounds = enough for a 9-inch pie

Best Uses

Snacking and eating raw: Ambrosia, Braeburn, Cameo, Cortland, Cripps Pink (branded as Pink Lady®), Empire, Fuji, Gala, Golden Delicious, Granny Smith, Honeycrisp, Jazz™, Jonagold, Macoun, SugarBee®, SweeTango™, Winesap
Why? In general, these apples don't brown quickly when cut, so they make a good choice in lunch boxes and snack bags.

Salads: Ambrosia, Cortland, Fuji, Gala, Honeycrisp, Jonagold
Why? For salads, apples should hold their shape and be resistant to browning. They will add a touch of sweetness to slaws, green spring mixes, or spinach blends.

Pies and other baked goods: Braeburn, Crispin or Mutsu, Golden Delicious, Granny Smith, Honeycrisp, Idared, Jonagold, Jonathan, Macoun, McIntosh, Northern Spy, Pink Lady®
Why? Apples used in pies and other baked goods should stay firm and hold their shape. Avoid varieties like Red Delicious or Gala that break down in high oven temperatures. Overly juicy apples (like Fuji or McIntosh) tend to make runny fillings that will require additional thickeners—cornstarch or flour. Remember, for best flavor and texture, use two or more varieties.

Applesauce and apple butter: Cortland, Fuji, Gala, Golden Delicious, Granny Smith, Honeycrisp, Idared, Jonagold, McIntosh, Northern Spy, Pink Lady®, Pippin, Winesap

Why? Sauced apples should easily cook down and be mashed to a desired consistency. Use a mix of varieties for a robust and complex flavor. A variety of different types makes the most flavorful sauce. If preparing an unsweetened apple sauce or butter, use more sweet apples for balance.

Cider, juices, and beverages: Cortland, Gala, Gravenstein, Jonagold, Pippin, Rome Beauty, Winesap

Why? Tannin, acid, and sugar content are key attributes of cider apples. If you prefer a tart cider, select a tart apple and vice versa for a sweet cider. Many varieties bred specifically for making apple cider or hard (fermented) ciders are too astringent or bitter for eating out of hand; these cider apple varieties are not commonly sold in markets.

Storage

Many factors affect the length of time apples remain fresh, such as when they were harvested or if they have been washed or cut. While commercial operations can keep apples for up to 10 months under controlled conditions, you can store apples at home for a few months.

The best storage apples are the tart, thick-skinned ones like Granny Smith, Fuji, Rome, and McIntosh, Northern Spy, and Honeycrisp. Place them in a zip-top plastic storage bag with a few holes cut in it and keep in a crisper drawer in the refrigerator at 30 to 35 degrees. For larger quantities, place in a cardboard box in a cool place like a basement or a root cellar. Ideally, wrap each apple with brown kraft paper or newspaper.

Storage Time:

Whole, unwashed apples

Room temperature: about a week

Cool, dark pantry: up to 3 weeks

Refrigerator: 1 to 2 months or up to 5 days if cut or sliced

Storage Tips:

- Do not wash apples until ready to prepare and eat.

- Do not peel, core, or cut/slice until ready to prepare and eat.

- Store in the refrigerator, ideally in a crisper drawer.

- Wrap apples individually.

- Do not store apples with cabbage, Brussels sprouts, potatoes, or carrots. The ethylene gas that apples naturally exude may cause these veggies to sprout and/or turn bitter or yellow.

Ripening

Apples, like bananas and tomatoes, are climacteric, which means they continue to ripen after harvest, becoming softer, juicier, and sweeter as starches change into sugars.

Climacteric foods that travel long distances are often harvested "green" because the firm, immature fruit is less likely to bruise or overripen. As apples ripen, they naturally produce ethylene gas, which encourages additional ripening. Distributors keep apples in controlled environments and often treat the bins to prevent ethylene from encouraging any additional ripening.

You can take advantage of an apple's ethylene production to ripen other fruit. To try it, place unripe fruit in a bag or sealed container alongside an apple. This works with unripe avocados, figs, mangoes, or peaches. Keep in mind that this technique does not work with non-climacteric foods—those that do not continue to ripen after picking, such as grapes, lemons, limes, oranges, raspberries, pineapple, squash, or watermelon.

Browning

When cut, the cells inside the apple are exposed to oxygen. Certain enzymes and phenolic compounds, naturally occurring in plants in varying degrees, react with oxygen, resulting in enzymatic browning. You'll notice this happening in other foods like bananas, avocados, and potatoes. While unsightly in apples, this biochemical reaction also occurs in black tea, coffee, and cocoa—foods you expect to be dark. The good news is that the browning does not make the fruit unsafe to eat. A few things inhibit enzymatic browning: cool temperatures, acids, and blocking oxygen.

To discourage browning of sliced or chopped apples:

- Store in an airtight container in the refrigerator.

- Immerse in an acidic liquid such as apple juice, pineapple juice, or a teaspoon of lemon juice stirred into 1 cup of cold water.

- Cover with plastic wrap.

- Cover in caramel, honey, or sugar syrup.

Apple varieties that are very slow to brown: Ambrosia, Cameo, Cortland, Cripps Pink or Pink Lady®, Empire, Gala, Ginger Gold, Granny Smith

Apple varieties that brown quickly: Pippin, Red Delicious

Nutrition

It's doubtful that whoever came up with the axiom, "An apple a day keeps the doctor away" knew that the juicy fruit contained healthy phytochemicals, but they did know a healthy snack when they saw it!

Apples contain almost no fat, no cholesterol, and low sodium but healthful amounts of vitamin C and impressive amounts of fiber. The fibers include insoluble and soluble, called pectin, which assists in digestion as well as increasing satiation, the fullness factor that can prevent overeating. The primary source of energy in an apple is carbohydrate, although apples are considered low glycemic because their carbs slowly convert to sugars and don't cause harmful spikes in blood sugar.

Apples contain quercetin, catechin, and chlorogenic acid—naturally occurring phytochemicals that provide protective health benefits such as preventing or reducing disease.

Many, if not most, of these nutrients are found in the peel, so for maximum nutrition, eat the apple whole.

Apple Varieties

Large grocery stores sell several types of apples, while a good farmers market will showcase dozens of varieties of apples. Although each apple variety's shape is similar, its color, taste, and texture are all remarkably different.

Top 10 Varieties Grown in the U.S:

1. Red Delicious
2. Gala
3. Golden Delicious
4. Fuji
5. Granny Smith
6. McIntosh
7. Honeycrisp
8. Rome
9. Empire
10. Cripps Pink, also known as Pink Lady®

Braeburn

COLOR: orange-red streaks over yellow

USES: snacking, salads, pies/baking, sauces, drying

FLAVOR: sweet and spicy

TEXTURE: crisp

SEASON: October–June

Ambrosia

COLOR: medium orange-red over yellow

USES: snacking, salads, pies/baking, sauces, cider, freezing

FLAVOR: sweet

TEXTURE: crisp

SEASON: year-round

Cameo

COLOR: bright red with orange streaks

USES: snacking, salads, pies/baking, sauces

FLAVOR: sweet-tart

TEXTURE: extra crisp

SEASON: September–October

Cortland

COLOR: red streaks with green blush

USES: snacking, salads, pies/baking, sauces, freezing, drying

FLAVOR: sweet to mildly tart

TEXTURE: tender

SEASON: September–April

Crispin or Mutsu

COLOR: Green-yellow

USES: snacking, pies/baking, sauces

FLAVOR: sweet

TEXTURE: firm

SEASON: October–September

Cosmic Crisp®

COLOR: wine red with light speckles

USES: snacking, salads, pies/baking

FLAVOR: balanced sweet and tangy

TEXTURE: crisp

SEASON: year-round

Empire

COLOR: dark red over green

USES: snacking, salads

FLAVOR: sweet-tart

TEXTURE: very crisp

SEASON: September–July

Cripps Pink or Pink Lady®

COLOR: pink blush over green-yellow

USES: snacking, salads, pies/baking, sauces, beverages, freezing

FLAVOR: sweet and tangy

TEXTURE: crisp

SEASON: November–July

Envy™

COLOR: ruby red with green undertones

USES: snacking salads, pies/baking

FLAVOR: sweet

TEXTURE: crisp

SEASON: October–March

Fuji

COLOR: bi-color pinkish-red over yellow

USES: snacking, salads, sauces, freezing

FLAVOR: sweet to spicy

TEXTURE: crisp

SEASON: year-round

Golden Delicious

COLOR: yellow-gold

USES: snacking, salads, pies/baking, sauces, freezing

FLAVOR: mildly sweet

TEXTURE: crisp

SEASON: year-round

Gala

COLOR: pinkish-orange stripes over yellow

USES: snacking, salads, pies/baking, sauces, freezing

FLAVOR: mildly sweet

TEXTURE: crisp

SEASON: August–March

Granny Smith

COLOR: green

USES: snacking, salads, pies/baking, sauces

FLAVOR: very tart

TEXTURE: crisp

SEASON: year-round

Ginger Gold

COLOR: golden yellow

USES: snacking, salads

FLAVOR: sweet to mildly tart

TEXTURE: fine and crisp

SEASON: August–November

Gravenstein

COLOR: Blush red with yellow stripes

USES: snacking, pies/baking, sauces, freezing

FLAVOR: tart

TEXTURE: firm

SEASON: September–December

Honeycrisp

COLOR: speckled red and pale green

USES: snacking, salads, pies/baking, sauces, freezing

FLAVOR: sweet to tart

TEXTURE: crisp

SEASON: September–February

Jonagold

COLOR: yellow with large flushes of red

USES: snacking, salads, sauces

FLAVOR: Sweet-tart

TEXTURE: crunchy

SEASON: October–May

Idared

COLOR: light red

USES: snacking, pies/baking, sauces, freezing

FLAVOR: sweet to tart

TEXTURE: firm

SEASON: October–August

Jonathan

COLOR: red stripes over yellow

USES: pies/baking

FLAVOR: spicy

TEXTURE: less firm

SEASON: September–April

Jazz™

COLOR: reddish-orange

USES: snacking, salads, pies/baking, sauces, beverages, freezing

FLAVOR: tangy

TEXTURE: crunchy and crisp

SEASON: September–July

Kanzi®

COLOR: red over yellow

USES: snacking, salads, pies/baking, beverages, freezing

FLAVOR: sweet-tart

TEXTURE: crunch

SEASON: March–June

Kiku®

COLOR: ruby red and yellow striped
USES: snacking, salads, pies/baking, sauces
FLAVOR: super sweet
TEXTURE: crunchy
SEASON: October–August

McIntosh

COLOR: red and green
USES: snacking, pies/baking, sauces, cider
FLAVOR: tangy
TEXTURE: tender
SEASON: September–July

Lady Alice

COLOR: orange-red over yellow
USES: snacking, salads, pies/baking, sauces, beverages
FLAVOR: sweet-tart
TEXTURE: crunchy
SEASON: January–May

Northern Spy

COLOR: orange-red to greenish yellow striped
USES: snacking, pies/baking, freezing
FLAVOR: moderately sweet
TEXTURE: crisp
SEASON: November–March

Macoun

COLOR: deep red to purple
USES: snacking, pies/baking
FLAVOR: extra sweet
TEXTURE: crisp
SEASON: October–November

Piñata

COLOR: orange/red over yellow
USES: snacking, salads, pies/baking, sauces
FLAVOR: sweet-tart
TEXTURE: crisp
SEASON: November–May

Pippin, Newtown or Albemarle Pippin

COLOR: light green to yellow green

USES: snacking, pies/baking, sauces, beverages

FLAVOR: sweet-tart

TEXTURE: crisp

SEASON: October–March

SugarBee®

COLOR: red-orange over yellow-green

USES: snacking, salads, pies/baking, beverages

FLAVOR: sweet

TEXTURE: crisp

SEASON: fall

Red Delicious

COLOR: deep red

USES: snacking, salads

FLAVOR: sweet and mild

TEXTURE: soft to mealy

SEASON: year-round

Sweetango™

COLOR: red with yellow blush

USES: snacking, salads, pies/baking

FLAVOR: very sweet

TEXTURE: crisp

SEASON: August–November

Rome or Rome Beauty

COLOR: deep red

USES: pies/baking, sauces

FLAVOR: mild

TEXTURE: firm

SEASON: October–September

Winesap

COLOR: dark red

USES: snacking, pies/baking, sauces, beverages

FLAVOR: spicy

TEXTURE: crisp

SEASON: October–February

jams,
sauces, and
beverages

Vanilla Blush Applesauce

For a pretty, pink-hued applesauce, use red-skinned apples and don't peel them before cooking. If you prefer a sweet applesauce, stir ½ cup packed light brown sugar into warm, blended applesauce. Let stand, stirring occasionally until sugar dissolves. If you are not into canning, the applesauce may be placed in zip-top plastic freezer bags and frozen up to 2 months.

makes 8 cups

INGREDIENTS
5 pounds apples, peeled, cored, and quartered
1 cup apple cider
1 tablespoon lemon juice
1 vanilla bean, split lengthwise

Prepare canning jars by sterilizing according to manufacturer's directions. Set aside.

Place apples in a large nonaluminum cooking pot. Stir in cider and lemon juice. Split vanilla bean in half lengthwise and scrape seeds into apple mixture. Place bean shells in pot with apples.

Bring mixture to a boil; reduce heat to medium-low. Cover and simmer 40 minutes, stirring occasionally, until apples are tender and falling apart.

Uncover and cool 10 minutes. Remove vanilla bean shells. Puree apple mixture with an immersion blender until smooth.

Ladle applesauce into prepared jars, leaving ½-inch headspace. Remove air bubbles. Wipe rims and apply lids and rings. Process jars in a boiling-water bath for 20 minutes. Remove jars from canning pot and set aside to cool to room temperature. Jars will "ping," which indicates that lids are sealed. The center of each lid will not flex up and down when pressed.

Ideal Apples: *Mix and match McIntosh, Cortland, Fuji, Braeburn, or Rome to achieve an interesting, complex flavor.*

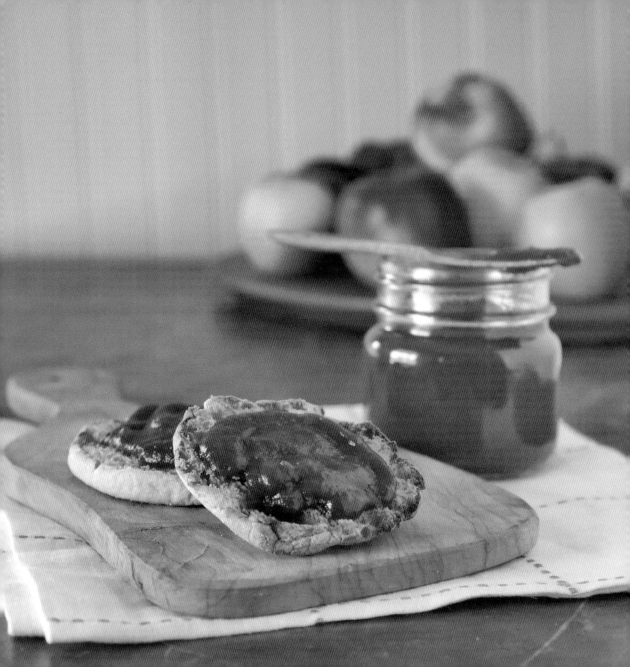

Slow-Cooker Apple Butter

makes 6 cups

INGREDIENTS
1 cup unsweetened apple juice
1 cup firmly packed light
 brown sugar
½ cup granulated sugar
1 tablespoon ground cinnamon
¼ teaspoon salt
¼ teaspoon ground cloves
1 tablespoon vanilla extract
5 pounds mixed variety
 of apples

Combine juice, sugars, cinnamon, salt, cloves, and vanilla in a 6-quart slow cooker.

Peel, core, and thickly slice or chop apples; stir into juice mixture.

Cook, covered, on low heat for 10 hours. Stir periodically, if convenient.

Puree mixture with an immersion blender. If mixture is thinner than applesauce, uncover and cook on high heat until thick (mixture will thicken more once cool).

Prepare canning jars by sterilizing according to the manufacturer's directions.

Ladle apple butter into prepared jars, leaving ½ inch headspace. Remove air bubbles. Wipe rims and apply lids and rings. Process jars in a boiling-water bath for 15 minutes. Remove jars from canning pot and set aside to cool to room temperature. Jars will "ping," which indicates that lids are sealed. The center of each lid will not flex up and down when pressed.

Ideal Apples: As with applesauce, apple butter has a more complex, interesting flavor when a few different varieties of apples are used. Use the same apples as you would for applesauce (McIntosh, Cortland, Fuji, Braeburn, or Rome) or choose spicier varieties like Winesap.

Spiced Apple Jelly Sauce

Serve over grilled chicken, pork, or ham slices. The jelly will scorch if brushed onto raw meat, so cook until almost done, and then brush over all sides until the sauce thickens and glazes over.

makes 1½ cups

INGREDIENTS
1 (18-ounce) jar apple jelly
2 tablespoons melted butter
1 tablespoon apple cider vinegar
1 tablespoon coarse-ground
 mustard
1 tablespoon Worcestershire
 sauce
1 to 2 teaspoons hot sauce

Combine jelly, butter, vinegar, mustard, Worcestershire, and hot sauce in a saucepan over medium heat. Cook, stirring frequently, until sauce is well blended.

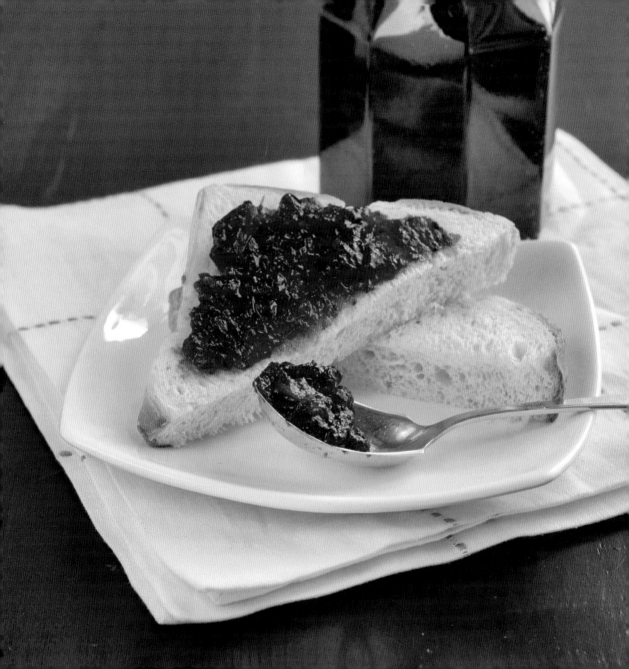

Apple-Cranberry Jam

Both apples and cranberries are naturally high in pectin, the component that causes food to "gel." That means you won't have to add supplements to get the jam to firm up, making this a great recipe for beginning canners. You can process the jam in large (1-pint) jars, but I like to use small, picnic-size jars to give as gifts.

makes 6 cups

INGREDIENTS

2 pounds (about 5) apples, peeled, cored, and coarsely chopped
1 (12-ounce) bag fresh cranberries
4 cups sugar
½ cup apple juice
2 teaspoons ground cinnamon
1 teaspoon ground nutmeg
¼ teaspoon ground cloves
1 teaspoon freshly grated lemon zest
¼ cup fresh lemon juice

Prepare canning jars by sterilizing according to the manufacturer's directions.

Place chopped apples in a large, heavy pot. Add cranberries, sugar, apple juice, cinnamon, nutmeg, cloves, zest, and lemon juice. Bring to boil over medium-high heat.

Reduce heat to medium. Cook, stirring frequently, for 30 minutes or until mixture thickens (jam will thicken more once cooled).

Ladle jam into prepared jars. Wipe rims and apply lids and rings. Process jars in a boiling-water bath for 10 minutes. Remove jars from canning pot and set aside to cool to room temperature. Jars will "ping," which indicates that lids are sealed. The center of each lid will not flex up and down when pressed.

Ideal Apples: Granny Smith, Pink Lady®, and Gala work well here.

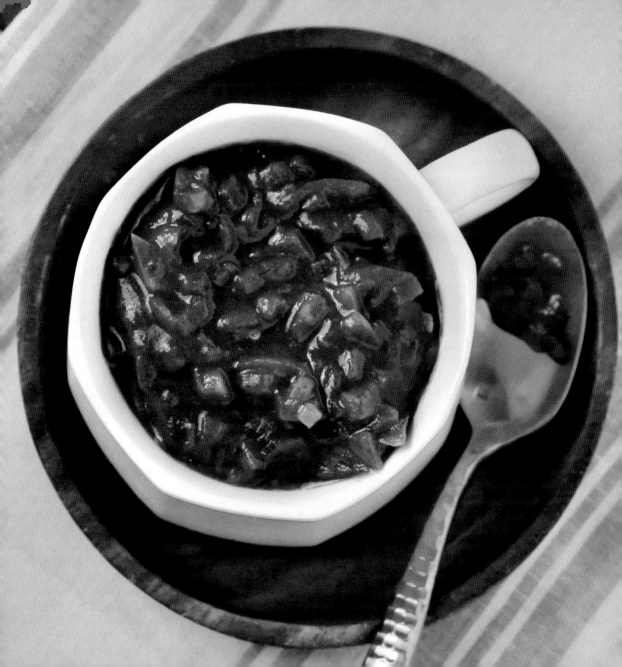

Apple Butter–Bourbon Sauce

Serve with bone-in chicken pieces, pork chops, or ham slices. Because the sauce contains sugar, bake or grill the meat until 10 minutes from being done. Brush all sides and continue cooking until sauce has caramelized and meat is coated.

makes 1½ cups

INGREDIENTS
2 tablespoons butter
1 onion, chopped
⅛ teaspoon crushed red
 pepper flakes
1 cup unsweetened apple juice
⅔ cup Slow-Cooker Apple
 Butter (page 27) or purchased
 apple butter
3 tablespoons apple cider vinegar
2 tablespoons Worcestershire
 sauce
2 tablespoons bourbon

Melt butter in a saucepan over medium heat. Add onion and red pepper flakes. Cook, stirring frequently, for 5 to 7 minutes or until onion is tender.

Stir in juice, apple butter, vinegar, and Worcestershire. Bring mixture to a boil. Reduce heat to medium-low and simmer 30 minutes, stirring occasionally until thickened. Stir in bourbon and cook 5 minutes.

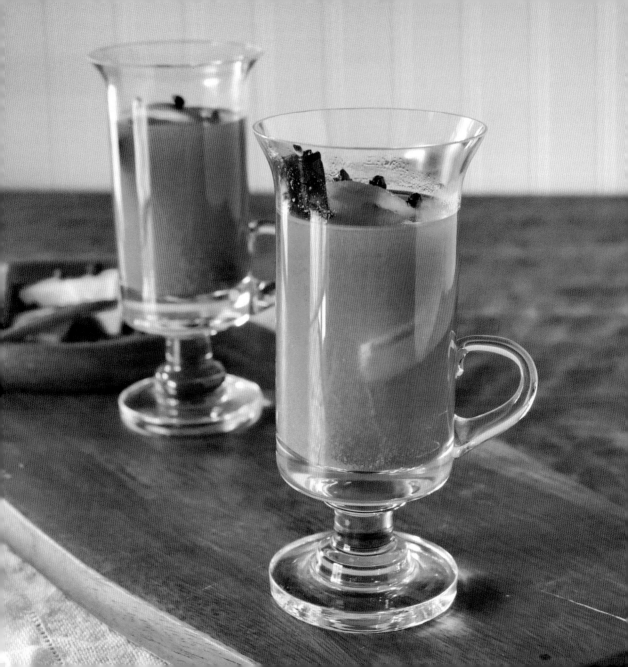

Hot Mulled Cider

Chilly fall and winter nights get a bit cozier with a glass of hot mulled cider. To make this more "adult," stir in 1 cup of spiced rum.

makes 8 cups

INGREDIENTS
½ gallon apple cider
2 navel oranges, halved and sliced
¼ cup firmly packed light brown sugar
1 (2-inch) piece fresh gingerroot, sliced
8 (2-inch) cinnamon sticks
1 teaspoon whole cloves
½ teaspoon allspice berries
5 whole star anise

GARNISH
Thin apple slices

Combine apple cider, oranges, brown sugar, ginger, cinnamon, cloves, allspice, and star anise in a large nonreactive (nonaluminum) pot.

Cook mixture over medium heat until hot but not boiling. Pour into 8 cups; garnish, if desired.

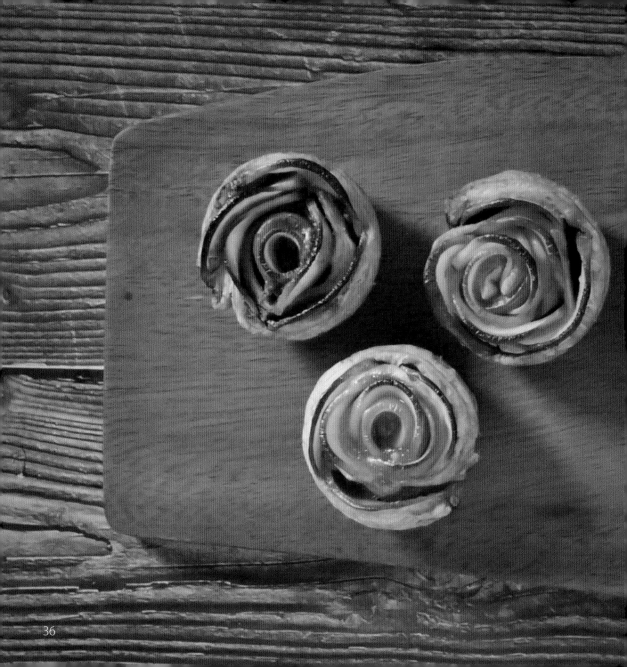

cookies, breads, and small bites

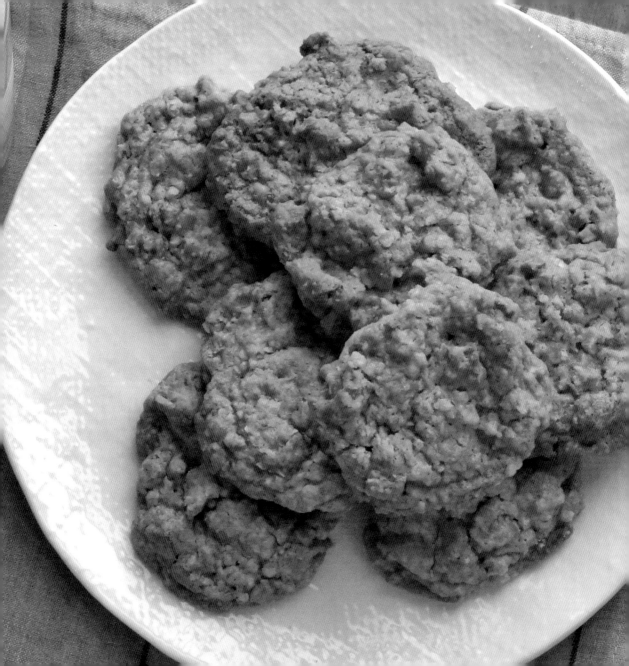

Toffee-Apple Oatmeal Cookies

Toffee pieces add a bit of crunchy texture to this sweet, lightly spiced cookie. Try white chocolate pieces as a variation or use the cookies as part of a homemade ice-cream sandwich.

makes 4 dozen

INGREDIENTS

2 sticks (1 cup) butter, softened
1 cup firmly packed light
 brown sugar
½ cup granulated sugar
2 large eggs
1 teaspoon vanilla extract
1½ cups all-purpose flour
1 teaspoon ground cinnamon
1 teaspoon baking soda
½ teaspoon salt
¼ teaspoon nutmeg
2 cups rolled oats
1 cup dried apples, chopped
1 (8-ounce) package
 toffee pieces

Preheat oven to 375°. Line 2 baking sheets with nonstick aluminum foil or parchment paper.

Beat butter and sugars in a large bowl with an electric mixer until light and fluffy. Add eggs and vanilla, beating until well blended.

Combine flour, cinnamon, soda, salt, and nutmeg in a medium bowl. Beat into butter mixture. Beat in oats, apples, and toffee pieces.

Drop dough by tablespoonfuls 2 inches apart on prepared baking sheets. Bake 10 to 12 minutes or until light golden brown. Cool in pan 1 minute; transfer to a wire rack and cool completely.

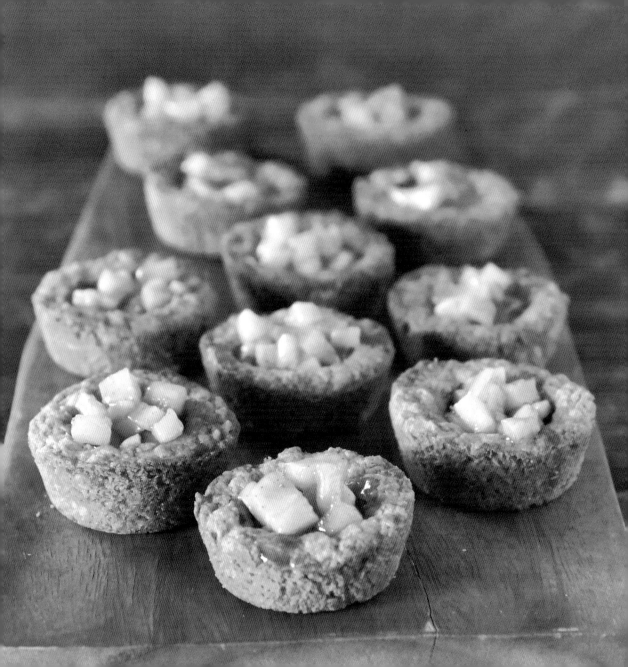

Apple Pie Cookie Cups

It's important to press the well in the center of the cookie while it is still warm and in the pan. Once the cookie cools, it will be become too firm.

makes 1 dozen

COOKIE CUPS
1 stick (8 tablespoons) butter
½ cup firmly packed light brown sugar
¼ cup granulated sugar
1 large egg
½ teaspoon vanilla extract
1 cup rolled oats
¾ cup all-purpose flour
½ teaspoon baking powder
¼ teaspoon ground cinnamon
⅛ teaspoon salt

APPLE FILLING
2 large apples
1 tablespoon butter
2 tablespoons granulated sugar
2 tablespoons light brown sugar
1 teaspoon cornstarch

Ideal Apples: Selecting a pie-friendly apple that doesn't water out isn't critical in this recipe because the filling is cooked and thickened. Use your favorite kind or any you happen to have on hand.

Preheat oven to 350°. Lightly grease a 12-cup muffin pan with cooking spray.

To make cups, beat 1 stick butter, ½ cup brown sugar, and ¼ cup granulated sugar in a large bowl with an electric mixer until light and fluffy. Add egg and vanilla; beat until well blended.

Combine oats, flour, baking powder, cinnamon, and salt in a medium bowl. Add to butter mixture, beating until well blended.

Divide dough evenly into muffin cups. Bake 15 to 18 minutes or until golden brown. Remove from oven; while warm, press in the center of each cup with a wooden tart tamper or spoon to create a well. Remove cookie cups from muffin pan and let cool on a wire rack.

While cups bake, prepare filling. Peel, core, and finely chop apples.

Melt 1 tablespoon butter in a skillet over medium heat. Add apples and cook 15 minutes or until softened. Stir in 2 tablespoons granulated sugar, 2 tablespoons brown sugar, and cornstarch. Cook, stirring constantly, 2 to 5 minutes or until apples are soft and mixture thickens. Spoon filling evenly into baked cups.

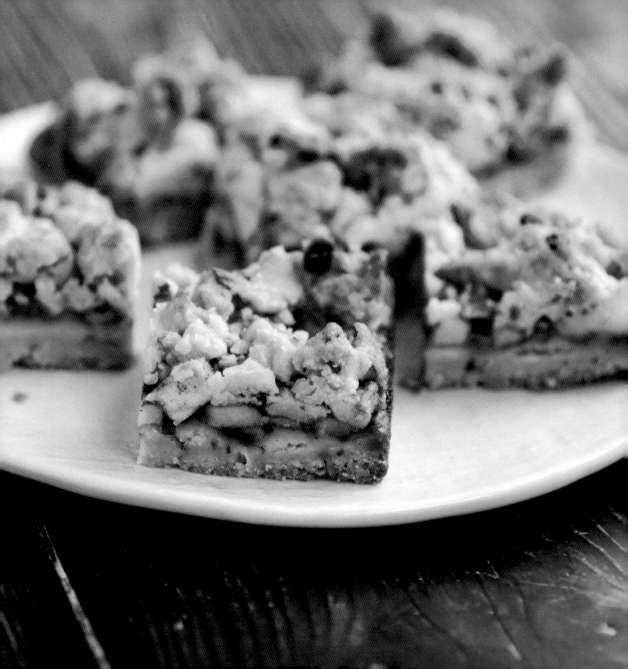

Nutty Apple Bars

This portable snack is a riff on an apple crumble—a fruit casserole with a sweet, flour-based topping. By creating a bottom crust, it becomes easy to cut into serving pieces.

makes 12 servings

INGREDIENTS

1¼–1½ pounds (3 large) apples
½ cup granulated sugar, divided
1 tablespoon cornstarch
1 teaspoon ground cinnamon
2 teaspoons lemon juice
2 cups all-purpose flour
½ cup finely chopped pecans
　　or walnuts
⅓ cup firmly packed light
　　brown sugar
1 cup butter, melted

Preheat oven to 375°. Lightly butter an 8-inch baking pan or line with nonstick aluminum foil.

Peel, core, and coarsely chop apples; place in a large bowl. Stir in ¼ cup granulated sugar, cornstarch, cinnamon, and lemon juice. Set aside.

Combine remaining ¼ cup granulated sugar, flour, pecans, brown sugar, and butter in a large bowl. Stir until well blended. Transfer ⅔ crust mixture to prepared pan and press into the bottom. Bake 15 minutes.

Remove pan from oven and spoon apple mixture and any liquid evenly over crust. Sprinkle evenly with remaining ⅓ crust mixture.

Bake 35 minutes or until golden brown. Cool in pan on a wire rack. Cut into squares or rectangles.

Ideal Apples: Use any one or a mix of your favorite baking apples such as Granny Smith, Golden Delicious, Rome, or Honeycrisp.

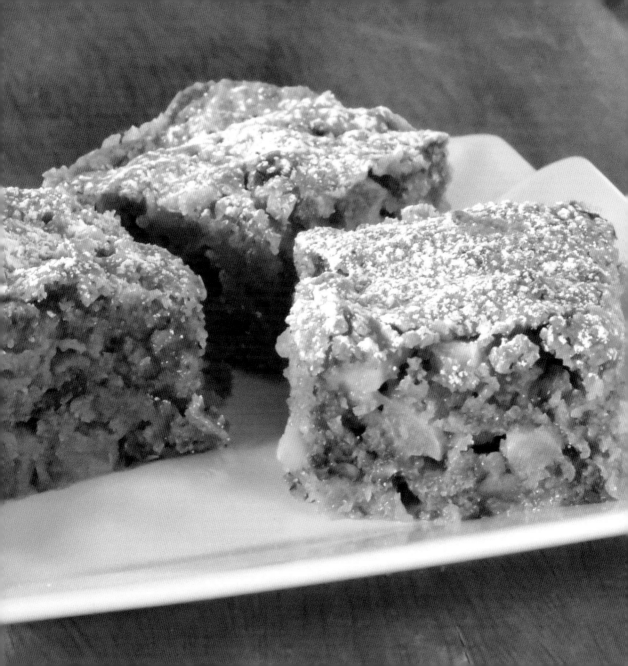

Apple Blondies

Blondies get their name because of their resemblance to brownies, but without the chocolate. These treats have a dark golden hue from the dark brown sugar and spices, plus tender, sweet apple bits blended throughout.

makes 16 servings

INGREDIENTS
1¼ cups all-purpose flour
½ cup granulated sugar
½ cup firmly packed dark
 brown sugar
1 teaspoon ground cinnamon
½ teaspoon baking powder
¼ teaspoon ground nutmeg
⅛ teaspoon ground cloves
1 large egg, lightly beaten
½ cup melted butter
1 teaspoon vanilla extract
2 large apples
½ cup chopped pecans

GARNISH
Powdered sugar

Preheat oven to 350°. Line an 8x8-inch or 9x9-inch baking pan with nonstick aluminum foil or lightly greased foil.

Combine flour, sugars, cinnamon, baking powder, nutmeg, and cloves in a large bowl. Whisk together egg, butter, and vanilla in a small bowl.

Peel, core, and coarsely chop apples. Stir egg mixture into flour mixture. Fold in apples and pecans.

Pour batter into prepared pan. Bake 30 to 35 minutes or until a toothpick inserted in center comes out clean. Cool completely and cut into 1½- to 2-inch squares. Garnish, if desired.

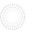

Ideal Apples: Use a good baking apple with a bit of sweetness like Winesap, Rome, or Fuji.

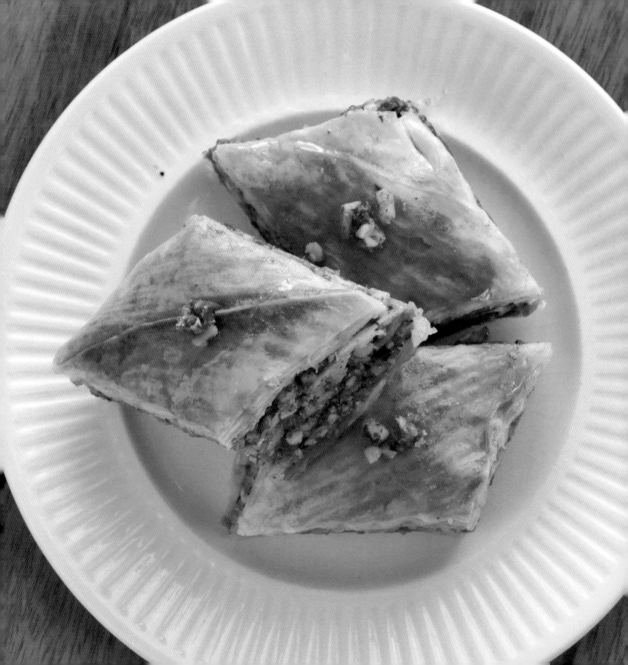

Apple Baklava

Thaw phyllo dough in the refrigerator overnight and keep it covered until ready to use. Be sure to pace yourself when brushing with butter—it's easy to go heavy in the beginning and then run out on the last couple of sheets. Store baklava in the refrigerator, but allow it to reach room temperature before eating.

makes about 2½ dozen

INGREDIENTS

2 sticks (1 cup) butter
1 cup slivered almonds
1 cup chopped walnuts
1 cup chopped pecans
1½ teaspoons ground cinnamon
½ teaspoon ground nutmeg
⅛ teaspoon ground cloves
1 cup dried apples, chopped
¼ cup sugar
1 (16-ounce) package frozen
 and thawed phyllo dough
Spiced Honey Syrup
 (recipe at right)

Preheat oven to 350°. Butter a 13x9-inch baking pan.

Melt 2 sticks butter in a saucepan over low heat. Keep warm. Process almonds, walnuts, pecans, cinnamon, nutmeg, and cloves in a food processor until very finely chopped. Add apples and sugar. Pulse until finely chopped. Set aside.

Place 1 sheet phyllo in bottom of pan. Brush with melted butter. Top with 9 sheets phyllo, brushing each with butter after placing in pan. Sprinkle ¾ cup apple mixture over phyllo. Top with 5 sheets phyllo, brushing each with butter. Repeat layers with remaining apple mixture and 5 sheets buttered phyllo. Top with remaining sheets buttered phyllo. Refrigerate baklava 15 minutes or until firm. Cut all the way through into a 1½-inch-wide diamond pattern.

Bake 45 minutes or until golden brown. Place pan on a wire rack. Pour Spiced Honey Syrup over top, allowing to seep into cut edges. Let stand at room temperature several hours.

Spiced Honey Syrup: Combine **1 cup sugar, ½ cup honey, ⅓ cup no-sugar-added apple juice, 2 tablespoons lemon juice**, and **⅛ teaspoon ground cinnamon** in a saucepan over medium heat. Bring to a boil, reduce heat to low, and simmer 10 minutes. Cool to room temperature.

Apple Puff Roses

If the honey is thick and difficult to spread, heat it for a few seconds in the microwave. Almond or pecan butter makes a great addition or substitution for the honey. It won't spread easily, so just dabble it along the length of the pastry.

makes 6 servings

INGREDIENTS

1 cup water
1 teaspoon lemon juice
2 large red apples
1 tablespoon sugar
⅛ teaspoon ground cinnamon
1 frozen and thawed puff
 pastry sheet
2 tablespoons honey

Ideal Apples: Use your favorite apple in this delightful treat. Red apples will create the most obvious "petals."

Preheat oven to 375°. Heavily grease 6 cups in a muffin pan with cooking spray.

Combine water and lemon juice in a medium microwave-safe bowl. Cut apples in half; remove cores with a melon baller or spoon. Cut apples into very thin slices and place in water. Microwave 1 to 2 minutes or just until apples are pliable. Drain well.

Combine sugar and cinnamon in a small bowl. Set aside.

Roll puff pastry on a lightly floured surface into a 12x10-inch rectangle. Cut lengthwise into 6 slices.

Brush or dabble honey lightly on top of one pastry strip. Sprinkle with cinnamon-sugar mixture. Arrange apple slices, peel side up, continuously along the top of the pastry so apple slices are hanging off the top. Fold up bottom half of pastry (tops of apple slices will peek out). Roll up pastry in a spiral and place in a muffin cup. Repeat with remaining ingredients.

Bake 35 to 40 minutes or until pastry is puffed and golden brown. Run a knife around the edge of each cup and remove from pan before each rose cools (to prevent sticking).

Easy Apple Hand Pies

Purchased refrigerated piecrusts are a shortcut, but you can also use plain homemade Piecrust Dough (page 65) or the Spicy Pastry Dough used in Fruit-Stuffed Apple Dumplings (page 93). Homemade dough is a good choice if you want to cut out unusual shapes because you can easily re-roll the scraps.

makes 4 servings

INGREDIENTS

2 tablespoons granulated sugar
1 tablespoon light brown sugar
2 tablespoons all-purpose flour
¾ teaspoon apple pie spice
⅛ teaspoon salt
2 apples
2 purchased refrigerated piecrusts
1 tablespoon butter, cut into
 very small pieces
1 egg
1 teaspoon water

Preheat oven to 375°. Line a baking sheet with a silicone baking mat, nonstick aluminum foil, or lightly greased foil.

Combine sugars, flour, apple pie spice, and salt in a medium bowl.

Peel apples and remove cores. Slice thinly and add to sugar mixture, tossing to coat.

Place piecrusts on a very lightly floured surface. Cut each in half. Spoon apple mixture evenly in bottom center of each pastry. Dot evenly with butter. Fold pastries in half, creating a triangle shape. Crimp edges.

Place on prepared baking sheet. Cut a few slits in top of each pastry. Whisk together egg and water; brush over pastries.

Bake 35 to 40 minutes or until filling is tender and bubbly and pastry is golden brown.

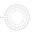

Ideal Apples: Granny Smith, Honeycrisp, Gala, Fuji, or other popular baking apples work best here.

Whole-Grain Apple Muffins

This whole-grain muffin has a bit less sugar than other recipes; sweetness is added with the fresh apple and dried cranberries. Keep the peel on the apple for maximum fiber and nutrition.

makes 1 dozen

INGREDIENTS
1½ cups rolled oats
1 cup whole wheat flour
¾ cup firmly packed light
 brown sugar
½ cup ground flax
2 teaspoons ground cinnamon
2 teaspoons baking soda
½ teaspoon baking powder
½ teaspoon salt
1 large egg
1 cup low-fat buttermilk
¼ cup canola oil
1 teaspoon vanilla extract
1 large apple
½ cup chopped walnuts
½ cup dried cranberries
 or raisins

Preheat oven to 350°. Line a 12-cup muffin pan with paper liners.

Combine oats, flour, brown sugar, flax, cinnamon, baking soda, baking powder, and salt in a medium bowl. Whisk together egg, milk, oil, and vanilla in a small bowl. Core apple and coarsely chop.

Add egg mixture to flour mixture, stirring just until moistened. Gently fold in apple, walnuts, and cranberries.

Spoon batter evenly into prepared muffin cups. Bake 18 minutes or until a toothpick inserted in center of each muffin comes out clean. Cool 5 minutes in pan; remove and cool on a wire rack.

Ideal Apples: Use any firm baking apple such as Golden Delicious, Jonagold, Fuji, or Granny Smith.

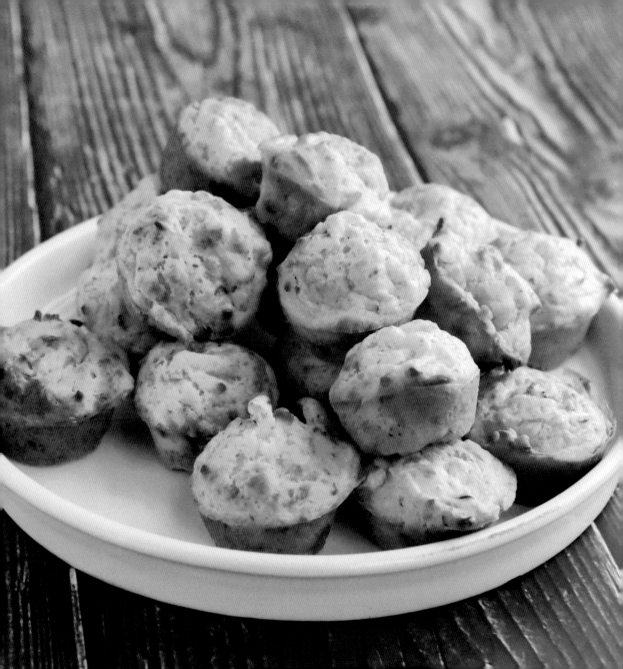

Herbed Apple Mini Muffins

Serve these little breads as a side to hot tomato soup or pile them up on a platter when serving brunch for a crowd (they make a good snack while indulging in pre-meal Bloody Marys!).

makes 3 dozen

INGREDIENTS

2 cups all-purpose flour
2 teaspoons baking powder
½ teaspoon salt
½ teaspoon cracked
 black pepper
¼ teaspoon cayenne pepper
1 cup (4 ounces) freshly grated
 Parmesan cheese
1 tablespoon chopped
 fresh rosemary
1 teaspoon chopped fresh chives
1 large egg
1½ cups milk
⅓ cup extra virgin olive oil
1 large apple

Preheat oven to 375°. Lightly grease cups of mini muffin pan(s) with cooking spray.

Combine flour, baking powder, salt, black pepper, and cayenne pepper in a medium bowl. Stir in Parmesan cheese, rosemary, and chives.

Whisk together egg, milk, and oil in a small bowl. Peel apple, if desired. Grate apple into egg mixture, avoiding core.

Add egg mixture to flour mixture, stirring just until moistened. Spoon batter into prepared cups, filling ¾ full.

Bake 15 minutes or until muffins are a light golden brown and a toothpick inserted in center of each comes out clean. Remove muffins and cool on a wire rack.

Ideal Apples: Use a not-too-tart and not-too-sweet baking apple such as Golden Delicious or Honeycrisp.

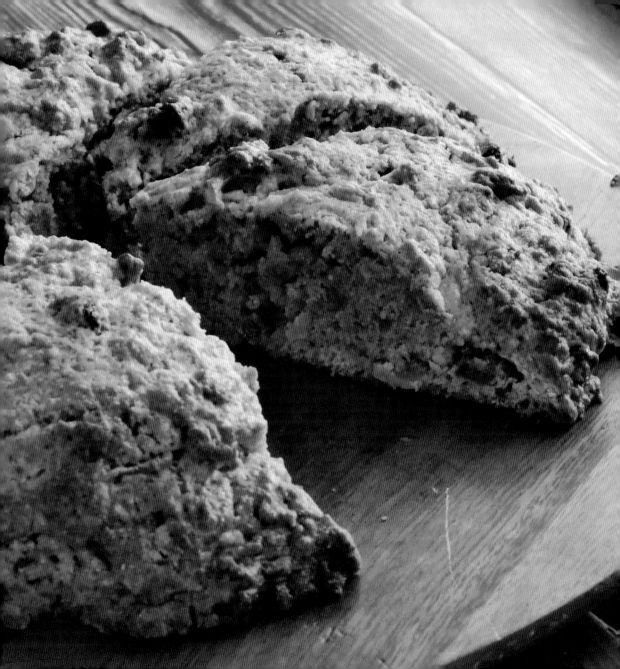

Apple-Cinnamon Scones

This scone is a little bit sweeter than common plain scones and almost crosses the line into a sweet bread. Still, make these for out-of-town guests or on any morning you want the family to feel special.

makes 8 scones

INGREDIENTS

2½ cups all-purpose flour
½ cup sugar
1 teaspoon ground cinnamon
½ teaspoon baking soda
¼ teaspoon salt
1 stick (8 tablespoons) butter, cut into small pieces
½ cup dried apples, chopped
¼ cup chopped crystallized ginger
1 large egg
¾ cup half-and-half
1 teaspoon pure vanilla extract

Preheat oven to 375°. Line a baking sheet with a silicone baking mat, parchment paper, or nonstick aluminum foil.

Place flour, sugar, cinnamon, baking soda, and salt in a food processor. Pulse a few times to combine. Add butter and pulse until mixture resembles coarse meal. Add apples and ginger; process until blended.

Add egg, half-and-half, and vanilla. Pulse just until mixture comes together (dough will be sticky).

Place dough on prepared baking sheet and form a 1¼-inch-thick disc about 8 inches in diameter. Use a butter knife to slice the dough into 8 equal triangles.

Bake for 25 minutes or until lightly golden. Remove from oven and use a knife to completely separate scones from each other. Move scones slightly away from each other; return to oven and bake for another 2 to 4 minutes or until edges of scones appear dry and tops are completely golden.

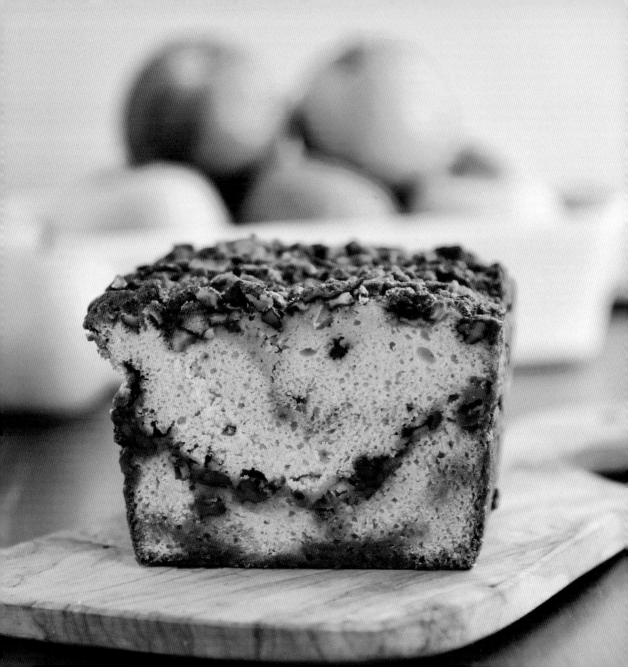

Apple-Cinnamon Quick Bread

The fruity streusel filling (and topping) adds sweetness and texture to this loaf that can double as a treat for afternoon tea or a simple dessert.

makes 1 (9x5-inch) loaf

INGREDIENTS

2 tablespoons melted butter
½ cup firmly packed light brown sugar
1½ teaspoons ground cinnamon
¼ teaspoon ground allspice or ground nutmeg
2 apples
½ cup chopped walnuts
1½ cups all-purpose flour
1½ teaspoons baking powder
¼ teaspoon salt
1 stick (8 tablespoons) butter, at room temperature
¾ cup granulated sugar
2 large eggs
2 teaspoons vanilla extract
½ cup half-and-half

Preheat oven to 350°. Grease and flour a 9x5-inch loaf pan.

Combine 2 tablespoons melted butter, brown sugar, cinnamon, and allspice in a medium bowl, stirring until well blended. Peel, core, and finely chop apples; place in bowl with brown sugar mixture. Add walnuts, stirring until blended; set aside.

Combine flour, baking powder, and salt in a medium bowl.

Beat 1 stick butter and granulated sugar in a large bowl with an electric mixer until light and fluffy. Beat in eggs and vanilla.

Add flour mixture to butter mixture, alternating with half-and-half. Pour half of batter into prepared loaf pan. Top with half of apple mixture. Pour remaining batter in loaf pan and top with remaining apple mixture.

Bake for 55 to 60 minutes or until a toothpick inserted in center comes out clean. Cool in pan 10 minutes; remove from pan and cool completely on a wire rack.

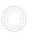

Ideal Apples: Use any crisp baking apple such as Granny Smith, Jonagold, Pink Lady®, or Fuji.

Apple Cheddar Biscuits

Consider keeping extra ingredients on hand because these light and highly flavorful biscuits will disappear fast. Best right out of the oven, they reheat well and make a nice addition to light lunches of soup and salad.

makes 1 dozen

INGREDIENTS

2 cups all-purpose flour
1 tablespoon baking powder
1 tablespoon granulated sugar
½ teaspoon salt
½ teaspoon coarsely ground black pepper
3 green onions, chopped
1 cup (4 ounces) shredded cheddar cheese
1 stick (8 tablespoons) butter, melted
1 cup sour cream
1 large apple, any variety

Preheat oven to 400°. Line a baking sheet with a silicone baking mat, nonstick aluminum foil, or lightly greased foil.

Combine flour, baking powder, sugar, salt, pepper, and onion in a large bowl, stirring until well blended. Add cheese, tossing to coat.

Combine butter and sour cream in a large bowl. Grate apple over bowl, avoiding the core. Stir until well blended. Stir butter mixture into flour mixture.

Pat dough out to ¾- to 1-inch thickness on a floured surface. Cut biscuits with a 2-inch cutter, patting scraps and cutting as necessary.

Place biscuits on prepared baking sheet and bake 15 minutes or until lightly browned.

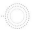 *Ideal Apples: Choose any firm baking apple or one of these: Honeycrisp, Golden Delicious, or Jonagold.*

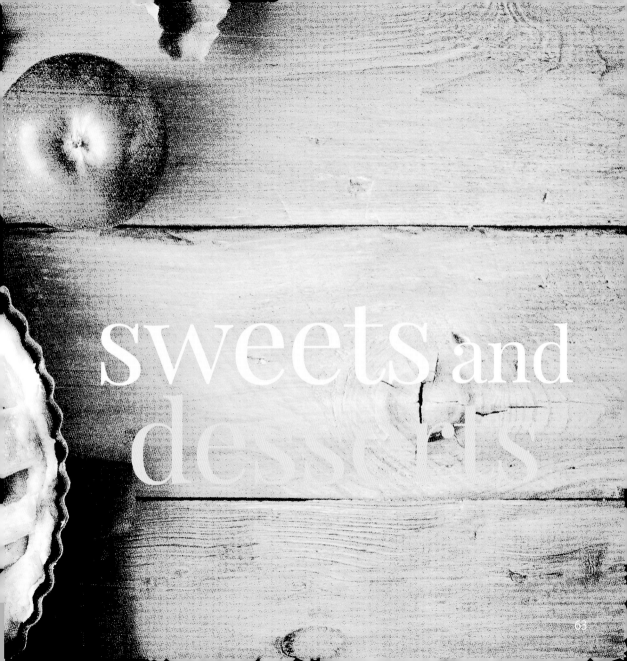

sweets and desserts

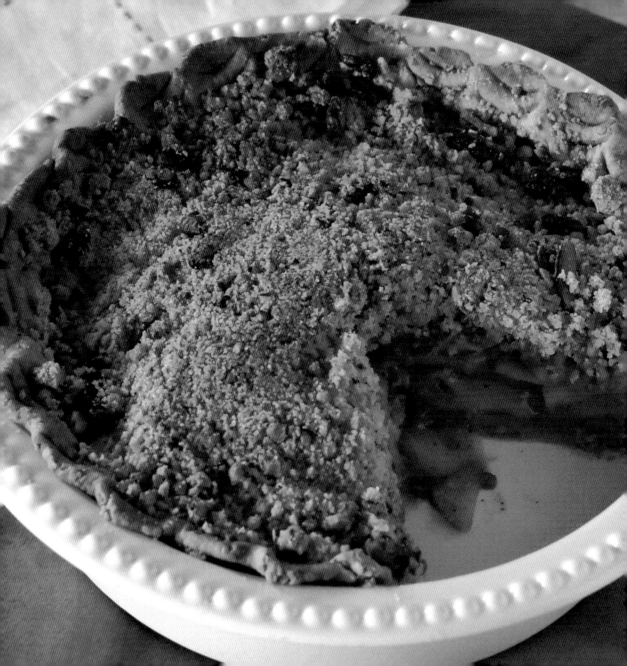

Open-faced Apple Pie with Salted Pecan Crumble

When I worked at *Coastal Living* magazine, my friend Simone Rathlé shared with me the yummy pie recipe from her husband, David Guas. If you are in the Northern Virginia area, be sure to stop by Bayou Bakery and try his other amazing New Orleans-style offerings. Shield pie with aluminum foil after 1 hour to prevent overbrowning.

makes 1 (9-inch) pie

INGREDIENTS
Piecrust Dough (recipe at right)
½ cup granulated sugar
2 tablespoons cornstarch
¾ teaspoon ground nutmeg
1 teaspoon freshly grated
 lemon zest
1¾ pounds (about 5) apples,
 peeled, cored, and sliced
Salted Pecan Crumble
 (recipe at right)

Ideal Apples: Use Granny Smith, Honeycrisp, or another baking apple.

Preheat oven to 350°. Fit dough into a 9-inch deep-dish pie plate; fold excess dough around edges and crimp. Refrigerate. Combine sugar, cornstarch, nutmeg, and zest in a bowl; stir until blended. Stir in apples. Spoon into center of piecrust. Top with Salted Pecan Crumble. Bake 1¼ to 1½ hours or until apples are tender and topping is golden brown.

Piecrust Dough: Pulse **1½ cups all-purpose flour** and **¼ teaspoon salt** in a food processor until combined. Add **4 tablespoons butter**; pulse until crumbly. With processor running, gradually add **¼ cup cold water**; process until dough gathers together. Remove and knead lightly to combine. Roll into a ¼-inch-thick circle on a lightly floured surface. Cover and chill 30 minutes. **Note:** Double recipe if you need 2 piecrusts.

Salted Pecan Crumble: Pulse **½ cup all-purpose flour, ¼ cup light brown sugar, 2 tablespoons granulated sugar, ¼ teaspoon salt, ¼ teaspoon ground cinnamon,** and **¼ cup chopped pecans** in a food processor until blended. Add **5 tablespoons butter**; pulse until blended. Transfer mixture to a bowl; stir in **¼ cup pecans** with hands, mixing and squeezing to form larger pieces. Cover and chill. Makes 1½ cups.

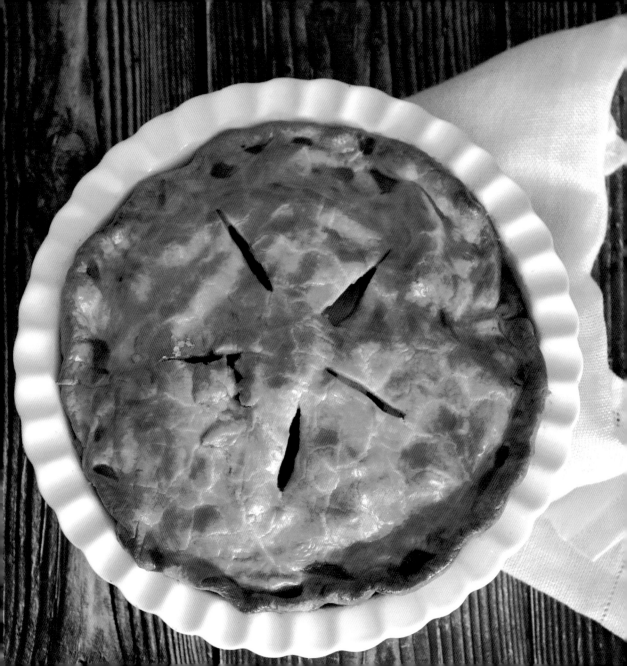

Easy Double Crust Apple Pie

It's important that steam escapes from double-crust pies, so cutting vents is critical. Hot steam and bubbly filling will eventually escape, and the shortest route is usually through the side seams. That means drips in the bottom of your oven! Venting also prevents a soggy top crust or a pie with a large gap between its filling and crust.

makes 1 (9-inch) pie

INGREDIENTS
2½ pounds (about 6 large) apples
2 tablespoons lemon juice
¾ cup firmly packed light brown sugar
¼ cup all-purpose flour
¾ teaspoon ground cinnamon
¼ teaspoon ground nutmeg
2 purchased refrigerated piecrusts or double batch of Piecrust Dough (page 65)
2 tablespoons butter, cut into small pieces
1 large egg
1 teaspoon water

Preheat oven to 400°.

Peel, core, and thinly slice apples; place in a large bowl. Add lemon juice, stirring to coat. Stir in brown sugar, flour, cinnamon, and nutmeg.

Fit 1 piecrust in the bottom of a 9-inch deep-dish pie plate. Spoon apple mixture into crust. Dot with butter. Place second piecrust over filling. Press edges of dough together and crimp decoratively, if desired. Cut a few slits in the top for steam to vent.

Combine egg and 1 teaspoon water; brush over top of pie.

Bake 15 minutes. Reduce heat to 350° and bake 1 hour or until apple filling is tender and bubbly. Cover loosely with aluminum foil if top crust gets too dark before filling is done. Cool to room temperature before slicing.

Ideal Apples: Green apples contain the most pectin, making Granny Smith perfect for pies because you want clean slices.

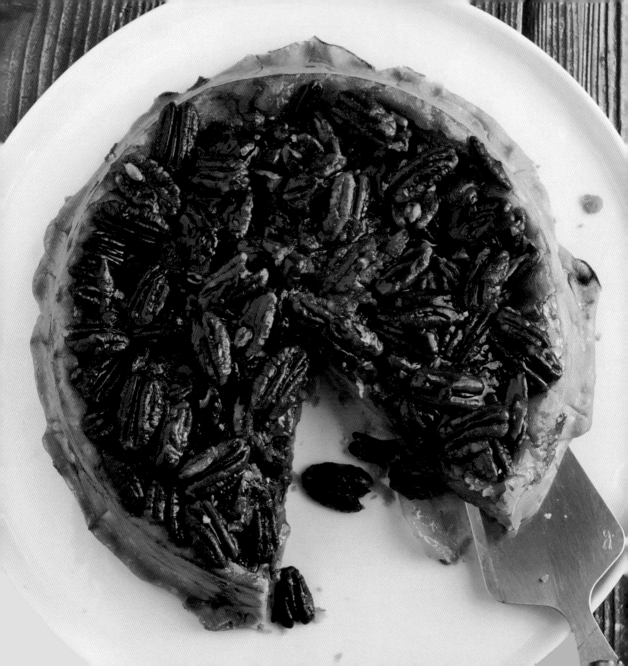

Upside-down Apple–Pecan Pie

Allow the pie to cool for a few minutes, but be sure to invert it onto a serving plate while it is still warm to allow the pecans and syrup to settle on top of the pie without sticking to the foil.

makes 8 servings

INGREDIENTS

1 cup pecan halves

⅔ cup firmly packed light brown sugar

6 tablespoons melted butter, divided

2 purchased refrigerated piecrusts or double batch of Piecrust Dough (page 65)

¼ cup granulated sugar

3 tablespoons all-purpose flour

1 teaspoon ground cinnamon

½ teaspoon nutmeg

¼ teaspoon salt

1 teaspoon freshly grated lemon zest

1 tablespoon fresh lemon juice

2 to 2¼ pounds (about 6) apples, peeled, cored, and cut into thin wedges

Preheat oven to 425°. Line a 9-inch deep-dish pie plate with nonstick aluminum foil or lightly greased foil.

Combine pecans, brown sugar, and 4 tablespoons melted butter in a bowl, stirring until pecans are coated. Spoon into bottom of prepared pie plate. Place 1 piecrust over pecans, allowing excess crust to hang over edge of pie plate.

Combine sugar, flour, cinnamon, nutmeg, and salt in a bowl. Stir in lemon zest and juice. Place apple slices in bowl with sugar mixture; gently toss apples to coat. Spread apple mixture evenly over crust.

Place remaining crust over filling. Fold the bottom crust over the top crust. Seal and flute edges. Cut 4 or 5 slits in top crust to vent steam.

Bake 10 minutes; reduce temperature to 350°. Continue to bake 40 to 45 minutes or until apples are tender and crust is golden brown. Cool pie for 10 minutes on a wire rack. Carefully invert onto a serving platter. Peel off foil.

Ideal Apples: Use a mix of firm, tart, and tangy baking apples: Granny Smith, Northern Spy, Jonathan, or Rome.

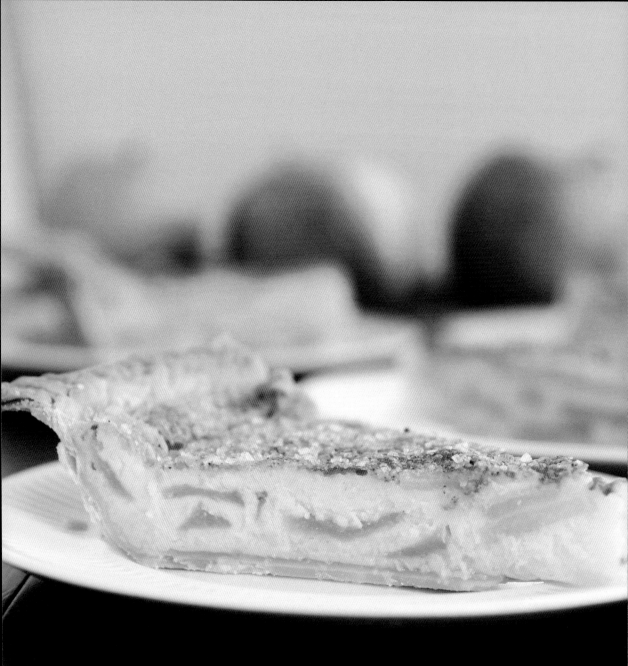

Apple Custard Pie

Creamy custard pies can acquire a soggy bottom crust. To avoid this, par-bake the crust just until it's set but not over-browned.

makes 8 servings

INGREDIENTS

1 purchased refrigerated piecrust or Piecrust Dough (page 65)
6 tablespoons butter, divided
3 small Granny Smith or Honeycrisp apples, peeled, cored, and thinly sliced
1 cup sugar, divided
1 tablespoon vanilla rum or rum (optional)
2 tablespoons all-purpose flour
⅛ teaspoon ground nutmeg
3 large eggs
1 cup heavy cream

Ideal Apples: The recipe calls for Granny Smith or Honeycrisp, but you can also use mild baking apples with old-fashioned heritage appeal like Northern Spy, Jonathan, or Baldwin.

Preheat oven to 325°.

Fit piecrust into a 9-inch pie plate; crimp edges, if desired. Prick bottom and sides of crust with a fork. Place a piece of parchment paper or aluminum foil over crust and fill ⅔ full with pie weights, dried beans, or rice. Bake 10 minutes. Remove weights and parchment carefully. Return crust to oven and cook 5 minutes or just until set.

Melt 2 tablespoons butter in a skillet over medium heat. Add apples and ¼ cup sugar. Cook, stirring occasionally, 5 to 8 minutes or until apples are tender. Stir in rum, if desired. Set aside.

Melt remaining 4 tablespoons butter and transfer to a medium bowl. Stir in remaining ¾ cup sugar, flour, and nutmeg. Add eggs and cream, whisking until eggs are completely blended into mixture.

Spoon apple mixture, with liquid, into bottom of piecrust. Pour cream mixture over apple mixture.

Bake 50 minutes or until center of pie is set. Cool completely on a wire rack. Serve at room temperature or chilled.

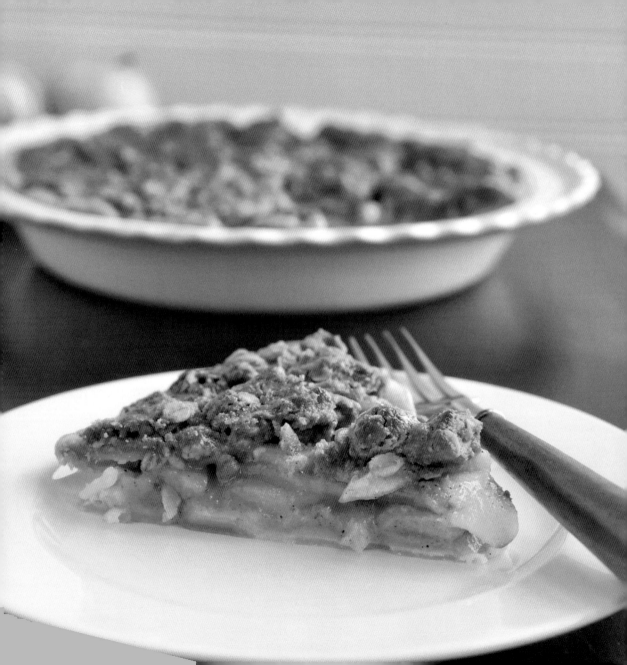

Dutch Apple Crumble Pie

Instead of a plain pastry crust, a Dutch apple pie features a cinnamon-oat streusel topping that will remind you of spiced oatmeal or a soft granola cereal.

makes 1 (9-inch) pie

INGREDIENTS

½ cup granulated sugar
2 tablespoons cornstarch
1 teaspoon freshly grated
 lemon zest
½ teaspoon ground nutmeg
2 pounds apples (about 6)
1 tablespoon fresh lemon juice
½ cup all-purpose flour
½ cup firmly packed light
 brown sugar
½ cup rolled oats
½ teaspoon ground cinnamon
1 stick (8 tablespoons) butter,
 cut into small pieces
1 purchased refrigerated piecrust
Vanilla ice cream (optional)

Preheat oven to 400°.

Combine granulated sugar, cornstarch, zest, and nutmeg in a large bowl, stirring until well blended.

Peel, core and slice apples. Add apples and lemon juice to sugar mixture, tossing to coat. Set aside.

Combine flour, brown sugar, oats, and cinnamon in a medium bowl. Cut butter into flour mixture with a pastry blender or fork until mixture is crumbly and evenly blended.

Fit piecrust into a 9-inch pie plate; crimp or decoratively pinch edges, if desired. Spoon apple mixture into crust. Sprinkle with oat mixture.

Bake 15 minutes. Reduce heat to 350° and bake an additional 30 minutes or until filling is bubbly and topping is golden brown. Cool completely before cutting and serving. If desired, warm pie slices in microwave 30 seconds and top with ice cream.

 Ideal Apples: Use Honeycrisp, Jonathan, Braeburn, Granny Smith, or another baking apple.

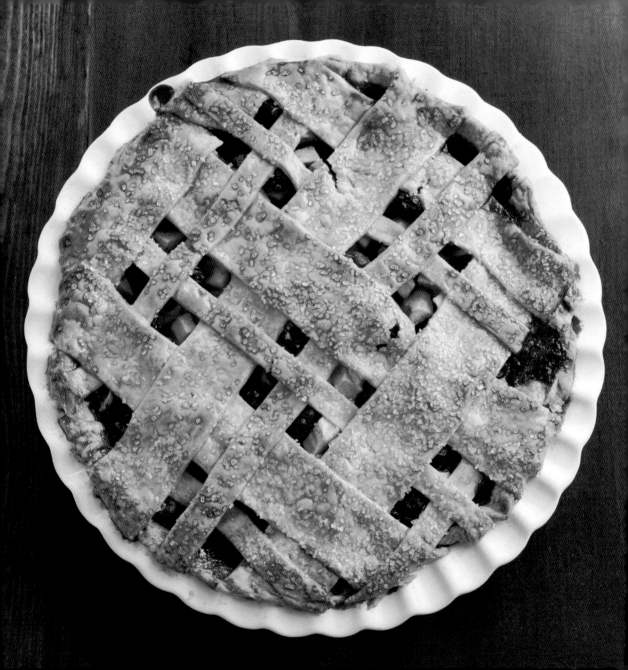

Apple-Cranberry Lattice Pie

On a silicone baking mat, parchment paper, or aluminum foil, weave piecrust strips into a lattice pattern, pressing lightly. Carefully flip lattice strips on top of filling, rearranging any lattice strips that fall out of place. Peel away silicone baking mat, parchment, or foil. Seal and crimp edges.

makes 1 (9-inch) pie

INGREDIENTS

½ cup granulated sugar
¼ cup firmly packed light brown sugar
3 tablespoons cornstarch
1 teaspoon freshly grated orange zest
1 tablespoon fresh orange juice
1 teaspoon ground cinnamon
⅛ teaspoon salt
1½ pounds (about 4) apples, peeled, cored, and coarsely chopped
1 (12-ounce) bag fresh or frozen, thawed, and drained cranberries
2 purchased refrigerated piecrusts or double batch of Piecrust Dough (page 65)
1 large egg, lightly beaten
1 tablespoon water
1 tablespoon sparkling or coarse sugar

Preheat oven to 400°.

Combine sugar, brown sugar, cornstarch, zest, juice, cinnamon, and salt in a large bowl.

Add apples and cranberries to sugar mixture, tossing to coat.

Fit 1 piecrust in a 9-inch deep-dish pie plate. Spoon apple-cranberry mixture into piecrust. Cut remaining piecrust into strips. Weave piecrust strips into a lattice pattern on top of filling. Seal and crimp edges. Whisk egg and 1 tablespoon water together in a small bowl. Brush egg mixture over lattice top and sprinkle with sparkling sugar.

Place pie on an aluminum foil-lined baking sheet and bake 15 minutes. Reduce heat to 350° and bake an additional 45 to 55 minutes or until filling is hot and bubbly and top is golden brown. Shield edges with foil if browning too quickly. Cool completely on a wire rack. Serve at room temperature or chill until ready to serve.

Ideal Apples: Try it with Granny Smith, Gala, or Honeycrisp apples.

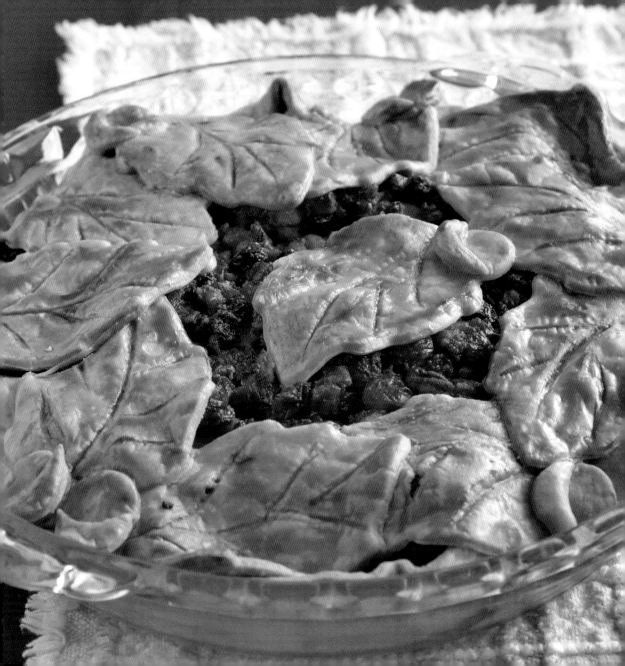

Mincemeat Pie

Original versions of mincemeat pies contained beef or beef suet. This modernized version skips the meat but adds a bit of butter instead. For a little spice, reduce the amount of golden raisins to ½ cup and add ½ cup minced crystallized ginger.

makes 1 (9-inch) pie

INGREDIENTS

1½ pounds (4 large) apples
⅓ cup dried apricots or dried cherries, finely chopped
1 cup golden raisins
1 cup currants
¼ cup chopped crystallized ginger
1 teaspoon orange zest
¼ cup orange juice
⅔ cup firmly packed light brown sugar
½ teaspoon ground cinnamon
¼ teaspoon ground cloves
¼ teaspoon ground allspice
1 tablespoon bourbon or brandy
2 tablespoons butter
⅔ cup chopped toasted walnuts or pecans
2 purchased refrigerated piecrusts or double batch of Piecrust Dough (page 65)
1 egg
1 teaspoon water

Peel, core, and coarsely chop apples. Combine apples, apricots, raisins, currants, ginger, orange zest, juice, and brown sugar in a large saucepan over medium heat. Bring mixture to a boil. Reduce heat to low and simmer, stirring occasionally, for 1 hour.

Stir in cinnamon, cloves, and allspice. Simmer 5 minutes. Stir in bourbon, butter, and walnuts. Cool completely.

Preheat oven to 425°.

Fit 1 piecrust into a 9-inch deep-dish pie plate. Spoon apple filling into piecrust. Top with remaining crust, or cut remaining crust into shapes or strips and arrange on top of pie. Seal and crimp edges.

Whisk egg and 1 teaspoon water together in a small bowl. Brush egg mixture over top. If using a whole crust, cut slits in top to vent steam.

Bake for 10 minutes. Reduce temperature to 350°. Bake 40 to 45 minutes or until filling is hot and bubbly and top is golden brown. Cool on a wire rack for 30 minutes. Serve warm or at room temperature.

Ideal Apples: Any baking apple will work, but because this is an old recipe, I like using heirloom varieties such as Northern Spy, Jonathan, Baldwin, or Winesap.

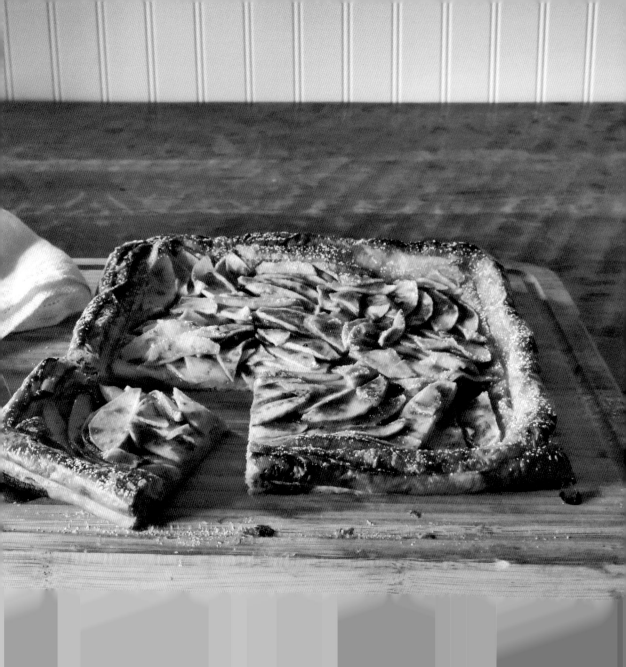

Simple Apple Tart

This pretty tart is remarkably easy and makes a great last-minute dessert, as long as you keep some puff pastry in your freezer and a couple of apples in the fridge. The edge of the puff pastry rises above the apple mixture, creating a frame to keep in the juices. Still, use a rimmed baking sheet in case some of the yummy syrup leaks out.

makes 6–8 servings

INGREDIENTS

1 sheet frozen puff pastry, thawed
1 large egg
1 teaspoon water
2 large apples
2 tablespoons melted butter
¼ cup brown sugar
1 tablespoon honey
¼ teaspoon ground cinnamon
Sifted powdered sugar (optional)

Preheat oven to 375°.

Roll puff pastry out on a piece of parchment paper or nonstick aluminum foil to remove seams. Beat egg and 1 teaspoon water together in a small bowl; brush over puff pastry. Score a ½-inch border around the pastry. Do not cut all the way through the pastry. Transfer to a rimmed baking sheet.

Peel apples and thinly slice. Place in a large bowl.

Stir together butter, sugar, honey, and cinnamon in a small bowl. Add to apples, folding gently until apples are coated.

Arrange apple slices evenly on pastry, inside the scored area. Drizzle with any liquid in the bowl.

Bake 30 to 35 minutes or until apples are tender and pastry is golden brown. Sprinkle lightly with powdered sugar, if desired, and cut into serving pieces.

 Ideal Apples: Granny Smith, Fuji, Gala, or Honeycrisp work well.

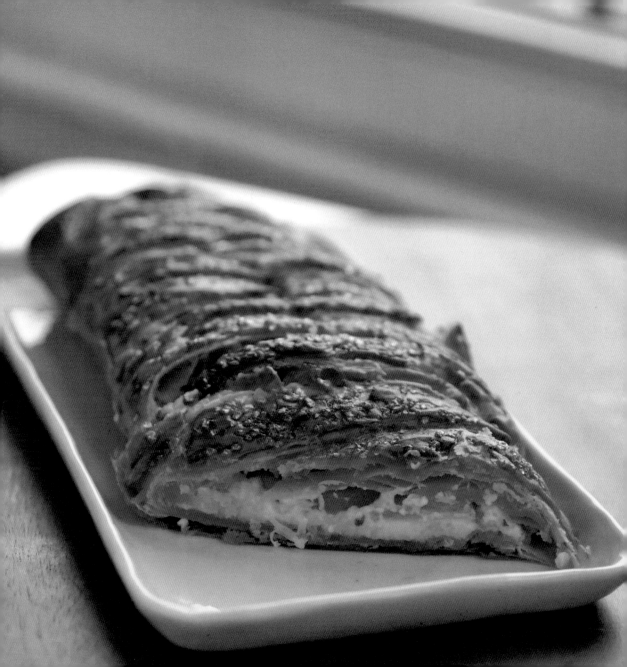

Cheese-Apple Danish

Puff pastry creates a light and crisp crust that surrounds a creamy and sweet apple filling.
Don't allow the puff pastry to become too warm when thawing or the dough will stick together.

makes 4 servings

INGREDIENTS

1 (8-ounce) package cream
 cheese, softened
⅓ cup sugar
1 large egg, separated
1 teaspoon vanilla extract
½ teaspoon freshly grated
 lemon zest
2 apples
1 frozen and thawed puff
 pastry sheet

Preheat oven to 400°. Line a baking sheet with a silicone baking mat, parchment paper, or nonstick aluminum foil.

Beat together cream cheese, sugar, egg yolk, vanilla, and zest in a medium bowl. Place egg white in a small bowl and set aside. Peel, core, and finely chop apples; set aside.

Unfold puff pastry out on a lightly floured surface. Turn pastry so the 2 seams are running vertically. Cut strips horizontally, about ¾-inch thick, from the 2 seams to the outer edge.

Spread cream cheese mixture into the center section of the pastry. Sprinkle evenly with apples. Fold side strips over filling, alternating each side so the strips crisscross and appear braided. Fold top and bottom pieces of puff pastry to seal in filling.

Brush top of pastry with egg white. Bake 25 minutes or until golden brown.

Ideal Apples: Use Granny Smith, Honeycrisp, Rome, or another baking apple.

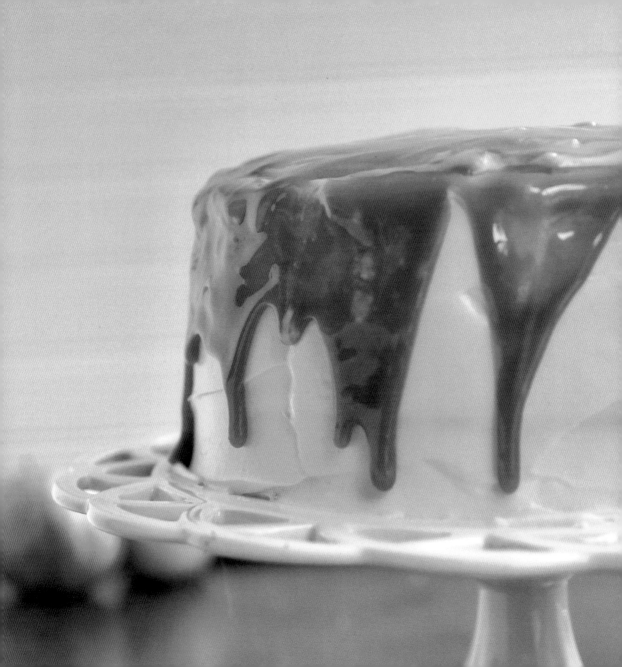

Apple Spice Cake with Butterscotch Drizzle

makes 1 (3-layer) cake

INGREDIENTS

3 sticks (1½ cups)
 butter, softened
1 cup granulated sugar
1 cup firmly packed light
 brown sugar
2 tablespoons molasses
2 large eggs
3 cups sifted cake or
 all-purpose flour
2 tablespoons ground cinnamon
2 teaspoons ground allspice
1 teaspoon ground nutmeg
1½ teaspoons baking soda
1 teaspoon baking powder
½ teaspoon salt
2 cups applesauce
3 apples, peeled
2 teaspoons vanilla extract
Cream Cheese Frosting
 (recipe at right)
Butterscotch Drizzle
 (recipe at right)

Preheat oven to 325°. Lightly grease 3 (8-inch) round cake pans with cooking spray. Line bottoms of pans with parchment paper. Lightly grease and dust with flour. Set aside.

Beat butter and sugars in a large bowl 3 minutes or until fluffy. Beat in molasses. Add eggs; beat until blended. Combine flour, cinnamon, allspice, nutmeg, baking soda, baking powder, and salt in a large bowl. Beat flour mixture into butter mixture, alternating with applesauce. Grate in apples, avoiding core. Stir in vanilla. Divide batter between prepared pans. Bake 30 minutes or until a toothpick inserted in center comes out clean. Cool in pans on wire racks 10 minutes. Remove from pans; cool. Top with Cream Cheese Frosting and Butterscotch Drizzle.

Cream Cheese Frosting: **Beat 2 (8-ounce) packages cream cheese, softened; 2 sticks (1 cup) butter, softened;** and **2 teaspoons vanilla** in a bowl on high speed with an electric mixer until creamy. Beat in **6 cups powdered sugar** on low speed. Beat at high speed until light and fluffy.

Butterscotch Drizzle: Combine **1 cup firmly packed light brown sugar, 3 tablespoons butter,** and **½ cup heavy cream** in a saucepan over medium heat. Cook, stirring frequently, 5 to 7 minutes or until thickened. Remove from heat and stir in **1 teaspoon vanilla**. Mixture will thicken as it cools.

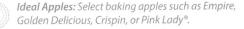

Ideal Apples: Select baking apples such as Empire, Golden Delicious, Crispin, or Pink Lady®.

Apple Bundt Cake with Maple Glaze

Bundt pans are a type of tube cake pan with rounded sides. In a wide variety of novelty shapes, the pans feature nooks and crannies that form a pattern. These spaces need to be well greased and floured to avoid sticking. Cooking spray is excellent; otherwise, use a pastry brush to spread butter or oil into the crevices.

makes 1 (10-inch) Bundt cake

INGREDIENTS

2½ cups all-purpose flour
¾ teaspoon baking soda
¾ teaspoon baking powder
¾ teaspoon ground cinnamon
½ teaspoon salt
½ teaspoon ground nutmeg
½ teaspoon ground ginger
⅛ teaspoon ground cloves
2 large apples
1 stick (8 tablespoons) butter,
 at room temperature
¼ cup vegetable oil
1 cup granulated sugar
1 cup firmly packed light
 brown sugar
4 large eggs
¾ cup unsweetened applesauce
Maple Glaze (recipe at right) or
 powdered sugar

Preheat oven to 350°. Coat a 10-inch Bundt pan with cooking spray and dust with flour.

Combine flour, baking soda, baking powder, cinnamon, salt, nutmeg, ginger, and cloves in a large bowl. Peel and core apples; coarsely chop.

Beat butter, oil, granulated sugar, and brown sugar in a large bowl with an electric mixture until creamy. Beat in eggs, one at a time. Gradually add flour mixture, alternating with applesauce. Fold in apples.

Pour batter into prepared pan. Bake 55 to 60 minutes or until a toothpick inserted in center comes out clean. Cool in pan 10 minutes; invert onto a wire rack and cool completely. Drizzle with Maple Glaze or dust with powdered sugar.

Maple Glaze: Combine **1½ cups powdered sugar, ¼ teaspoon ground cinnamon, ⅓ cup pure maple syrup,** and **1 teaspoon vanilla extract** in a bowl, whisking until smooth. If thick, add water by teaspoonfuls.

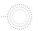
Ideal Apples: Use your favorite baking apples such as Granny Smith, Jonathan, or Braeburn.

Butterscotch Apple Cupcakes

Though the flavors are somewhat similar, the difference between butterscotch
and caramel is that butterscotch is made with brown sugar instead of granulated sugar.
(And in case you were wondering, toffee is just butterscotch that was cooked longer!)

makes 1½ dozen

INGREDIENTS

2 sticks (1 cup) butter, at
 room temperature
1 cup sugar
3 large eggs
1 tablespoon vanilla extract
2 large apples
2 cups all-purpose flour
1 teaspoon baking soda
½ teaspoon salt
½ teaspoon ground nutmeg
½ teaspoon ground cinnamon
1 cup unsweetened applesauce
Easy Butterscotch Frosting
 (recipe at right)

Preheat oven to 350°. Place 18 muffin cup liners in muffin pans.

Beat butter and sugar in a large mixing bowl with an electric
mixture until fluffy. Beat in eggs, one at a time; beat in vanilla.
Peel apples and grate into butter mixture, avoiding core. Stir
until batter is well blended.

Combine flour, baking soda, salt, nutmeg, and cinnamon.
Add flour mixture to apple mixture, alternating with apple-
sauce, beginning and ending with flour mixture. Spoon batter
into prepared cups, filling ¾ full.

Bake 20 minutes or until a toothpick inserted in center comes
out clean. Cool in pan 5 minutes; remove cupcakes from pan
and cool completely on wire racks. Pipe or spoon Easy Butter-
scotch Frosting on top of cupcakes.

Easy Butterscotch Frosting: Combine **4 tablespoons (¼ cup)
butter** and **½ cup firmly packed dark brown sugar** in a
medium saucepan over medium-low heat, stirring until sugar
melts. Bring mixture to a boil. Whisk in **2 tablespoons heavy
cream** or **milk** and **1 teaspoon vanilla extract.** Remove from
heat. Stir in **1¾ cups powdered sugar.** Spread over cupcakes
while frosting is still warm. Makes 1¼ cups.

*Ideal Apples: Use your favorite baking apple with lots of flavor:
Braeburn, Granny Smith, Crispin, or Pink Lady®.*

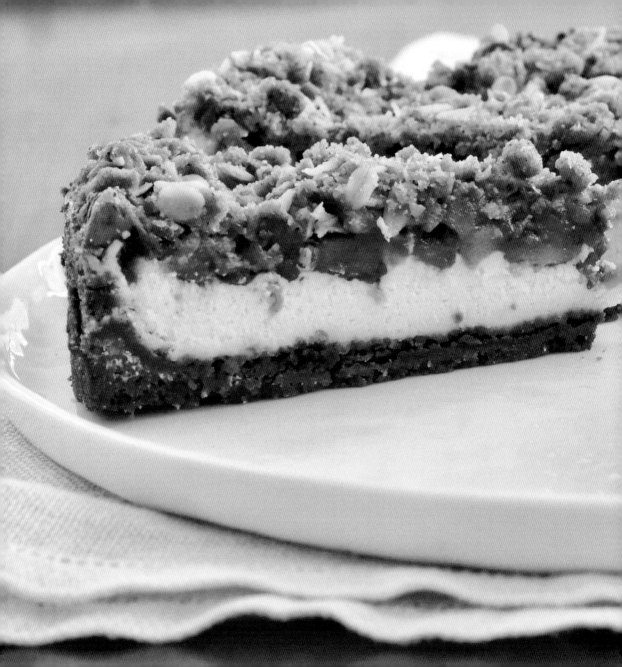

Apple Streusel Cheesecake

makes 12 servings

INGREDIENTS

2 (8-ounce) packages cream
 cheese, softened
½ cup sugar
2 large eggs
¼ cup milk
1 tablespoon all-purpose flour
1 teaspoon vanilla extract
¼ teaspoon salt
Gingersnap Crust
 (recipe at right)
Apple Pie Topping
 (recipe at right)
Crumble Topping
 (recipe at right)

Beat together cream cheese and sugar in a large bowl. Beat in eggs, milk, flour, vanilla, and salt. Spread cream cheese mixture evenly over Gingersnap Crust. Spoon Apple Pie Topping over cream cheese mixture. Sprinkle with Crumble Topping.

Bake 45 minutes. Let cool on a wire rack. Refrigerate to chill.

Gingersnap Crust: Preheat oven to 325°. Pulse **30 gingersnap cookies** in a food processor until finely ground. Add **¼ cup sugar** and **4 tablespoons melted butter**; pulse until blended. Press into a 9-inch deep-dish pie plate. Bake 12 minutes.

Apple Pie Topping: Peel, core, and coarsely chop **1½ pounds (3 to 4 medium-size) apples**. Melt **2 tablespoons butter** in a saucepan over medium heat. Add apples, **2 teaspoons lemon juice, ⅓ cup light brown sugar, 1½ teaspoons ground cinnamon**, and **¼ teaspoon ground nutmeg**, stirring until coated. Stir in **3 tablespoons apple juice**. Cover and cook, stirring occasionally, 10 to 12 minutes or until softened. Combine **1½ tablespoons cornstarch** and **2 tablespoons apple juice**; add to pan. Cook, stirring frequently, 1 to 2 minutes.

Crumble Topping: Combine **¼ cup all-purpose flour, ¼ cup rolled oats, ¼ cup firmly packed light brown sugar, ½ teaspoon ground cinnamon, ¼ teaspoon ground nutmeg**, and **2 tablespoons melted butter** in a medium bowl.

Ideal Apples: Sweet or tangy apples won't get lost in all the spicy flavor: Granny Smith, Pink Lady®, or Northern Spy.

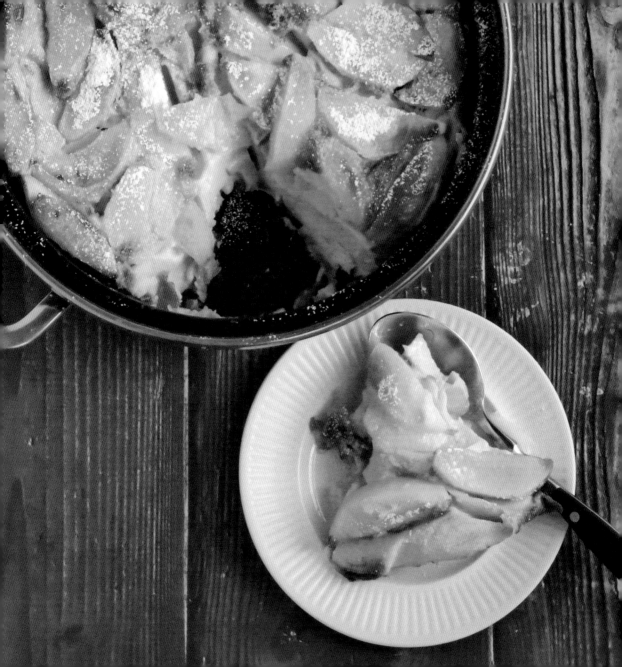

Baked Apple Clafouti

This baked custard dessert is so simple and makes a great option for dinner parties where you don't have time to fuss with a fancy dessert with lots of pots and pans. Just pop it in the oven when you serve your meal. And there are no worries if conversations run long and dessert is delayed, as this dish is delicious whether served warm or at room temperature.

makes 8 servings

INGREDIENTS

4 apples
4 large eggs
½ cup firmly packed light
 brown sugar
⅔ cup all-purpose flour
½ teaspoon salt
1½ cups half-and-half
6 tablespoons melted butter,
 divided
1 teaspoon vanilla extract
½ cup granulated sugar
2 tablespoons bourbon
 or brandy
Sweetened whipped cream
 (optional)
Powdered sugar (optional)

Preheat oven to 400°.

Peel, core, and slice apples; set aside.

Whisk together eggs, brown sugar, flour, salt, half-and-half, 3 tablespoons melted butter, and vanilla in a large bowl until smooth.

Pour remaining 3 tablespoons melted butter in a 10-inch seasoned cast iron or other ovenproof skillet. Add apples, granulated sugar, and bourbon. Cook, stirring frequently, for 5 minutes or until sugar dissolves and apples are almost tender.

Whisk egg mixture quickly (in case it has separated) and pour batter over fruit in skillet. (Baking the clafouti in the skillet is easiest, but you can transfer the fruit to a buttered baking dish and then top with batter, if you like.)

Bake 35 to 40 minutes. Serve warm or at room temperature with sweetened whipped cream or powdered sugar, if desired.

Ideal Apples: Use Pink Lady®, Granny Smith, Braeburn, or another firm baking apple.

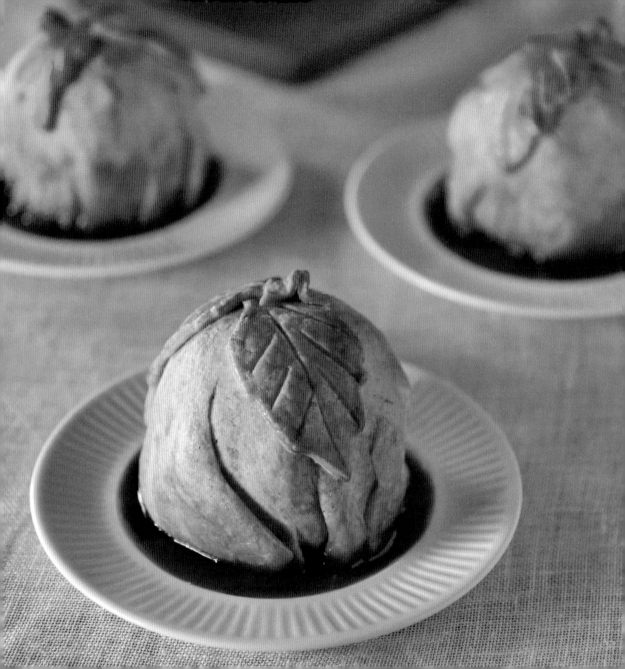

Fruit-Stuffed Apple Dumplings

These individual desserts are easier to make than they appear. Decorate the tops with excess pastry dough or cut leaves from purchased refrigerated piecrust dough.

makes 6 servings

INGREDIENTS

Spiced Pastry Dough
 (recipe at right)
1 cup firmly packed light
 brown sugar
¾ cup water
4 tablespoons (¼ cup) butter
½ teaspoon vanilla extract
½ cup mixed dried fruit such as
 cranberries and/or raisins
1 tablespoon finely chopped
 crystallized ginger
¼ cup granulated sugar
½ teaspoon ground cinnamon
6 firm baking apples, peeled
 and cored (leaving ¼ inch
 on bottom)

Ideal Apples: Use an apple that stands up to baking without getting mushy, such as Jonagold, Honeycrisp, or Granny Smith.

Prepare Spiced Pastry Dough; refrigerate. Combine brown sugar, ¾ cup water, and butter in a small saucepan over medium heat. Simmer 2 to 3 minutes or until melted and smooth. Stir in vanilla. Set aside.

Stir together fruit, ginger, granulated sugar, and cinnamon in a bowl. Spoon mixture evenly into the center of each apple.

Preheat oven to 375°. Line a 13x9-inch baking pan with nonstick aluminum foil or lightly greased foil.

Drape a pastry circle over each apple; press dough around bottom, covering entire apple. Place in prepared pan. Repeat with remaining dough and apples. Decorate with extra pastry. Pour brown sugar mixture over apples. Bake 50 minutes or until apples are tender and crust is golden brown.

Spiced Pastry Dough: Pulse **2 cups all-purpose flour, 2 teaspoons sugar, ½ teaspoon salt, ¼ teaspoon ground cinnamon,** and **⅛ teaspoon ground cloves** in a food processor until combined. Add **12 tablespoons cold butter**; pulse until crumbly. With processor running, gradually add **4 to 6 tablespoons cold water**; process until dough gathers together. Remove and knead lightly to combine. Divide dough into 6 pieces. Roll each piece into an ⅛-inch-thick circle. Cover and chill 30 minutes.

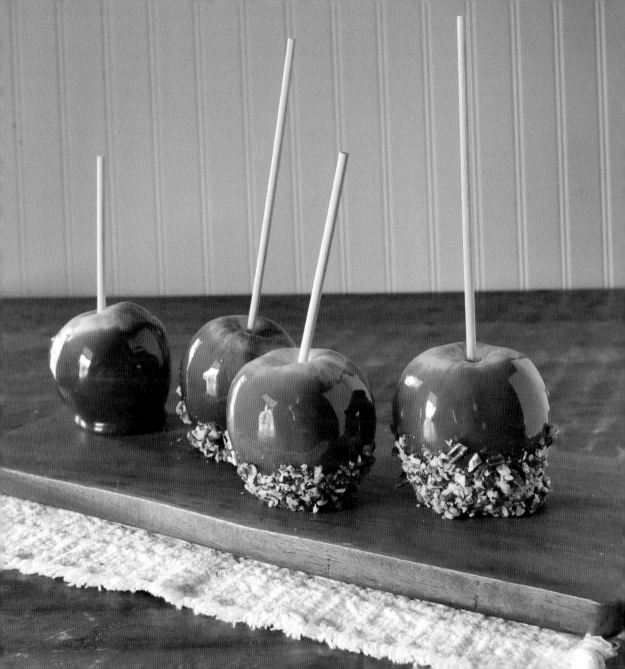

Caramel Apples

Nothing beats the flavor of caramel made from scratch. There are a few tricks to remember, but you'll find the caramel sauce easy after the first try. This recipe makes a little extra so it's easier to dip the apples. Use a silicone spatula to spread any remaining caramel on a silicone mat and sprinkle with flaky sea salt—yum! Be sure the apples are washed and dried. Any moisture or waxy coating will cause the caramel to slide down the apple.

makes 6 servings

INGREDIENTS

6 small to medium apples,
 chilled
1½ cups sugar
3 tablespoons light corn syrup
⅓ cup water
½ cup heavy whipping cream
2 tablespoons butter
1 teaspoon vanilla extract

TOPPINGS

chopped toasted nuts,
 mini chocolate chips,
 colored sprinkles

Wash apples and dry thoroughly. Place in the refrigerator until ready to dip (a chilled apple will set the caramel and reduce drips and runoff). Insert sticks into the tops of apples and place on a silicone baking mat or parchment paper-lined baking sheet. Set aside.

Combine sugar, corn syrup, and ⅓ cup water in a small saucepan over medium-high heat. Bring to a boil, stirring once or twice, just until sugar dissolves. Boil sugar mixture for 8 to 10 minutes or until mixture is deep golden brown and registers 320° on a candy thermometer. (Do not stir. If necessary, swirl the pan to make sure mixture is evenly colored and blended).

Carefully whisk in heavy cream, butter, and vanilla. Cook until mixture reaches 245°. Cool mixture until caramel is thickened but still liquid.

Dip apples into caramel, letting excess drip off. Roll in desired toppings and let cool about an hour on silicone mat.

Ideal Apples: Use tart apples, such as Granny Smith, Jonagold, Braeburn, or Jazz™, to balance the sweetness of the caramel.

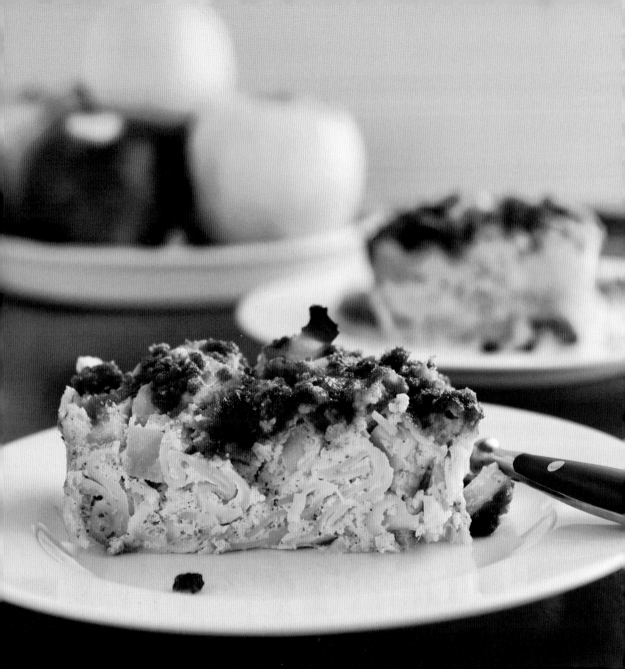

Apple Noodle Kugel

I was a little hesitant about adding this variation of kugel. As with any traditional holiday dish, the best version is the one you grew up with, made with love by your grandmother or mother. Still, you might find this interpretation interesting because apples replace the more commonly included raisins. I tend to add some type of topping to pasta or noodle casseroles to prevent a tough upper crust. Running out of panko breadcrumbs and substituting crushed gingersnaps turned the accident into a tasty new twist.

makes 8 servings

INGREDIENTS

12 ounces wide egg noodles
2 large apples
6 large eggs
¾ cup granulated sugar
1 (15-ounce) container
 ricotta cheese
1 (16-ounce) container
 sour cream
1 stick (½ cup) butter, melted
 and divided
1 teaspoon ground cinnamon
1 teaspoon vanilla extract
¾ cup gingersnap
 cookie crumbs
½ cup firmly packed light
 brown sugar

Preheat oven to 350°. Butter a 13x9-inch baking dish.

Cook noodles according to package directions until al dente; drain. Peel, core, and coarsely chop apples.

Beat eggs until well blended. Beat in granulated sugar, ricotta, sour cream, ¼ cup melted butter, cinnamon, and vanilla in a large bowl. Stir in noodles and apples. Pour into prepared dish.

Combine remaining ¼ cup melted butter, cookie crumbs, and brown sugar in a medium bowl. Sprinkle over noodle mixture.

Bake 55 minutes or until set in center. Cool 10 minutes before cutting into serving pieces.

Ideal Apples: Tart apples like Granny Smith or Honeycrisp keep their bite.

Almond–Apple Crisp

The difference between a crisp and a crumble is subtle—crisps usually include oats.
Use quick-cooking or old-fashioned, whatever you have on hand. For a distinct almond
flavor, add ¼ teaspoon almond extract to the butter that's drizzled over the apples.

makes 6 servings

INGREDIENTS

½ cup rolled oats
½ cup all-purpose flour
¼ cup packed light brown sugar
⅓ cup chopped sliced almonds
 or other nuts
½ teaspoon ground cinnamon
8 tablespoons butter, melted
 and divided
2 pounds (5 to 6 medium-size)
 apples

Preheat oven to 350°. Lightly grease a 6-cup baking dish with cooking spray.

Combine oats, flour, brown sugar, almonds, and cinnamon in a large bowl. Add 6 tablespoons butter, stirring until well blended (mixture will be lumpy).

Peel, core, and thickly slice apples. Place slices in bottom of prepared dish. Drizzle with remaining 2 tablespoons melted butter and stir lightly. Sprinkle with oat mixture.

Bake 45 minutes or until apples are tender and topping is golden brown.

*Ideal Apples: Try a mix of baking apples with a bit of tartness like
Granny Smith or Northern Spy.*

Sweet Apple Rice Pudding

Rice pudding has been around for a few centuries. Its nondescript color and subtle flavor take it out of "wow" dessert category, but the creamy dish is firmly entrenched in comfort food territory. Arborio is a short-grain rice used for risotto, and its creamy texture works well for this dessert. In a pinch, you can substitute long-grain rice.

makes 3 cups

INGREDIENTS
1 large apple
2 tablespoons butter
⅔ cup arborio rice
2 tablespoons Calvados or apple brandy (optional)
3 cups half-and-half
⅓ cup sugar
1 teaspoon vanilla extract
Ground cinnamon

Peel, core, and finely dice apple. If desired, save a piece and thinly slice for a garnish.

Melt butter in a large saucepan over medium heat. Add rice and apple; cook, stirring frequently, for 3 to 5 minutes. Stir in Calvados, if desired; cook, stirring constantly, until liquid is absorbed.

Stir in half-and-half and sugar. Bring to a boil over medium-high heat. Reduce heat to low and simmer 30 minutes, stirring occasionally, until rice is tender and mixture is creamy.

Remove from heat and stir in vanilla. Sprinkle servings evenly with a pinch of ground cinnamon.

Ideal Apples: Any apple you prefer will work, but you'll get the best results from one that doesn't get mushy when cooked. Try Jonagold, Pink Lady®, or Golden Delicious.

soups, salads, and savories

Roasted Apple–Parsnip Soup

Parsnips are available year-round, but they peak during fall and winter. When hit with frost, their starch converts to sugar, but many find the root a little bitter. Apples blend well and add a subtle sweetness that pairs nicely. Save a few pieces of sliced leek for garnish.

makes 7 cups

INGREDIENTS

3 large apples
1 pound parsnips
2 leeks
2 tablespoons extra virgin
 olive oil
1 teaspoon salt
⅛ teaspoon ground white pepper
⅛ teaspoon ground
 cayenne pepper
4 cups vegetable or
 chicken broth
1 cup heavy whipping cream
Crème fraiche or sour cream

GARNISH

Slivered leeks

Preheat oven to 425°.

Peel, core, and thickly slice apples. Peel and coarsely chop parsnips. Cut roots from leeks and halve lengthwise. Rinse well and cut into 2-inch pieces.

Combine apples, parsnips, leeks, oil, salt, white pepper, and cayenne pepper in a large bowl, tossing until coated. Spread on a rimmed baking sheet. Bake 30 minutes or until apple mixture is tender and slightly browned around the edges.

Transfer apple mixture into a soup pot. Stir in broth and whipping cream. Cook over medium-low heat 20 minutes or until mixture is thoroughly heated. Puree soup with an immersion blender until smooth. Divide soup evenly into 7 cups and dollop each with crème fraiche. Garnish, if desired.

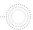

Ideal Apples: Any apple that breaks down when cooked will work well. Try a sweet-and-spicy Winesap, Gala, or McIntosh.

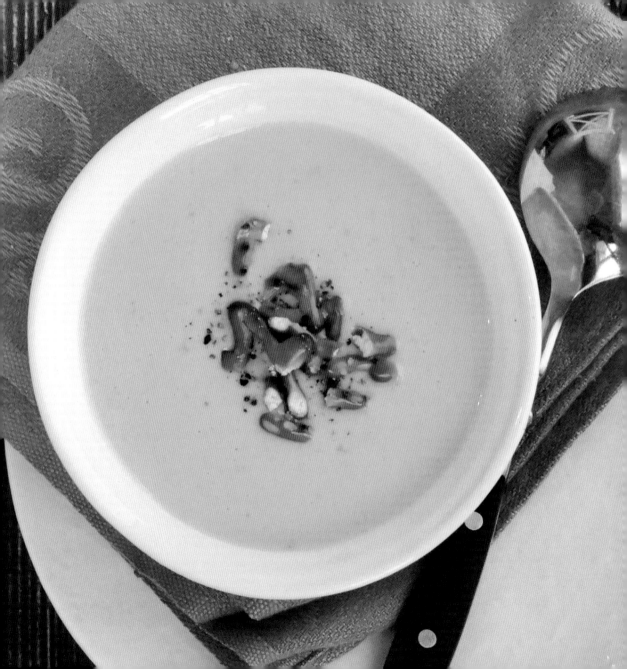

Apple-Cheddar Beer Soup

Try this rich and surprisingly filling soup at tailgate parties or any other fall get-together. You can vary the flavor a bit by substituting a smoked cheese. Pretzels pair well with these flavors, so sprinkle pieces of broken pretzels over the top as a fun, crunchy garnish.

makes 6 cups

INGREDIENTS

4 tablespoons butter
1 onion, chopped
⅛ teaspoon crushed red
 pepper flakes
2 large apples
2 teaspoons fresh thyme leaves
¼ cup all-purpose flour
1 (12-ounce) bottle beer
2 cups vegetable or
 chicken broth
2 teaspoons Worcestershire sauce
3 cups (12 ounces) shredded
 extra-sharp cheddar cheese
2 cups half-and-half or
 whole milk

GARNISH

Pretzel pieces

Melt butter in a soup pot over medium heat. Add onion and pepper flakes; cook, stirring occasionally, for 5 minutes. Meanwhile, peel, core, and chop apples.

Add apples and thyme. Cook, stirring frequently, for 5 minutes.

Reduce heat to low. Stir in flour and cook 3 minutes. Whisk in beer, broth, and Worcestershire. Cook, stirring frequently, for 30 minutes or until apples are tender.

Remove from heat and blend smooth with an immersion blender. Add cheese and half-and-half, stirring until blended and smooth. If necessary, cook soup over medium-low heat, stirring constantly, until cheese melts. Garnish, if desired.

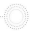

Ideal Apples: Sweet apples pair nicely with cheddar cheese. Try Gala, Honeycrisp, or Golden Delicious.

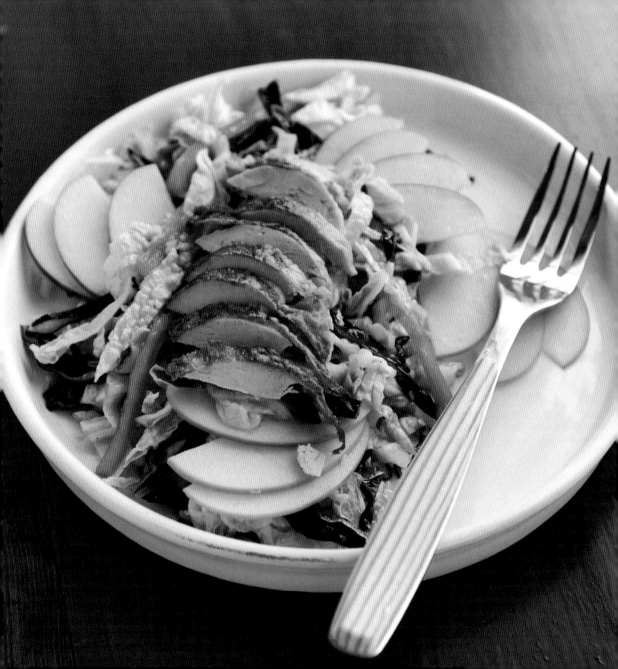

Chicken, Apple, and Napa Cabbage Salad

There is a lot of satisfying crunch to this salad that is hearty enough to serve as a whole meal. Napa cabbage is much more tender and sweet than head cabbage. Remove the tough white ribs from the outer leaves if they are pithy, and slice all parts of the interior leaves for extra bite.

makes 6 cups

INGREDIENTS

Applesauce-Soy Vinaigrette
 (recipe at right)
2 large apples
6 cups thinly sliced
 Napa cabbage
1 cup very thinly shredded
 red cabbage
1 yellow bell pepper,
 thinly sliced
1 cup snow peas, trimmed
4 cups shredded or sliced
 cooked chicken

Prepare Apple-Soy Vinaigrette and place about 2 tablespoons in a medium bowl. Core and thinly slice apples; add to bowl and toss in vinaigrette to coat (this will help prevent the apples from browning).

Combine Napa cabbage, red cabbage, bell pepper, and snow peas in a large serving bowl or platter. Add remaining vinaigrette, tossing to coat. Add apples, and gently toss. Add shredded chicken and toss gently or place sliced chicken on top of slaw for a more upscale presentation.

Applesauce-Soy Vinaigrette: Whisk together **½ cup unsweetened applesauce, 3 tablespoons soy sauce, 3 tablespoons apple cider vinegar, 2 tablespoons vegetable** or **light olive oil, 1½ tablespoons dark sesame oil,** and **1 teaspoon grated fresh ginger** in a small bowl. Makes 1 cup.

Ideal Apples: There are lots of intense flavors here, so pick an apple that is a little sweet and is delicious eaten raw. Try Fuji or Honeycrisp.

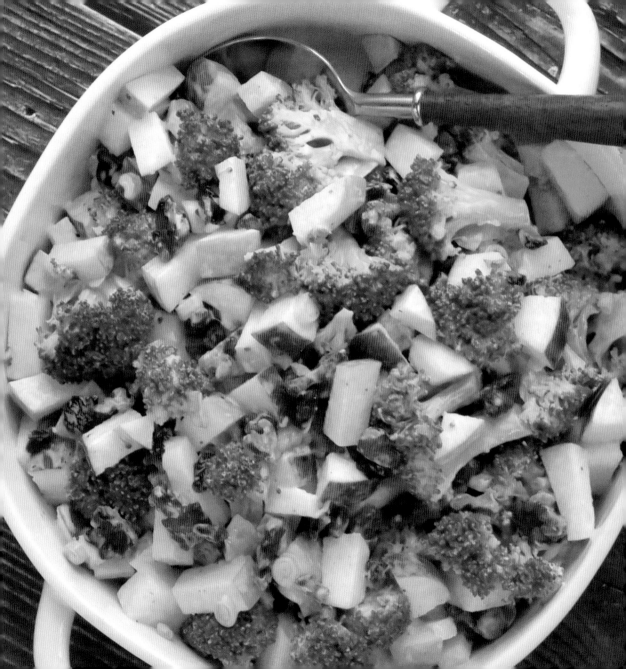

Broccoli-Apple Salad

Broccoli should be blanched before using. Cooking the broccoli for a short time and then immediately cooling it will help the vegetable retain its bright green color and crunchy texture. This recipe is vegetarian, but anyone who loves bacon knows that a few cooked and crumbled slices will only add to the yummy flavor.

makes 6 cups

INGREDIENTS

4 cups small broccoli florets
3 tablespoons mayonnaise
3 tablespoons plain yogurt or
 sour cream
1 tablespoon sugar
1 tablespoon hot sauce
¼ teaspoon salt
¼ teaspoon coarsely ground
 black pepper
3 small or 2 medium apples
3 green onions, chopped
⅓ cup dried cranberries
⅓ cup toasted sunflower seeds

Blanch broccoli in boiling salted water for 1 to 2 minutes or until bright green. Drain in a colander and rinse with cold water to cool. Set aside.

Combine mayonnaise, yogurt, sugar, hot sauce, salt, and pepper in a large bowl. Core and chop apples; add to mayonnaise mixture. Stir in broccoli, green onions, cranberries, and sunflower seeds; toss to coat.

Ideal Apples: The best apple to use in salads is one that tastes great raw and doesn't brown when chopped or sliced. Choose Honeycrisp, Empire, Jazz™, or Fuji apples.

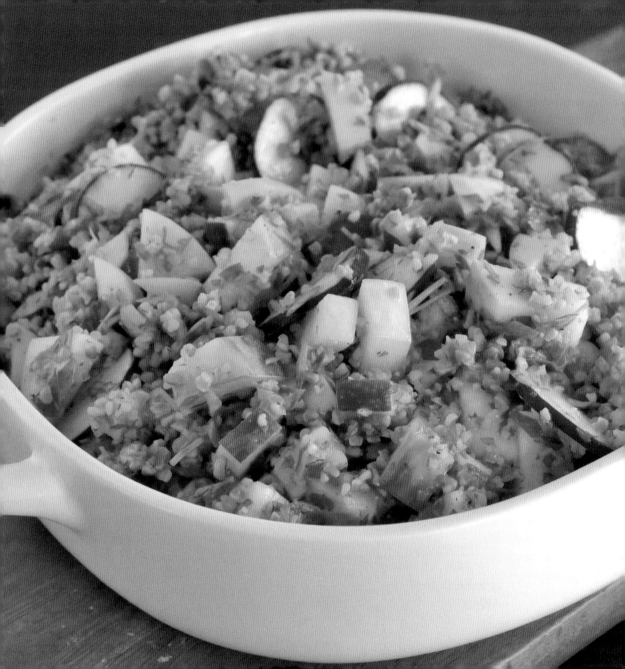

Apple Tabbouleh Salad

Bulgur is a whole-grain wheat product with a chewy texture and nutty flavor.
A great gluten-free substitute for bulgur would be quinoa or rice. Cook either
according to package directions and combine with remaining ingredients.

makes 7 cups

INGREDIENTS
1 cup bulgur wheat
2 cups vegetable or
 chicken broth
¼ cup extra-virgin olive oil
¼ cup apple cider vinegar
1 teaspoon sugar
½ teaspoon salt
¼ teaspoon coarsely ground
 black pepper
1 garlic clove, minced
4 radishes, trimmed and
 thinly sliced
½ cup chopped fresh
 flat-leaf parsley
3 green onions, minced
2 large apples

Combine bulgur and broth in a medium saucepan over
medium heat. Cover and bring to a boil. Reduce heat to
medium-low; simmer until tender, about 10 minutes.
Drain any excess broth; cool to room temperature or chill.

Whisk together oil, vinegar, sugar, salt, pepper, and garlic in
a large bowl. Add cooked bulgur, radishes, parsley, and green
onion, tossing to coat.

Core apples and chop; add to bulgur mixture, tossing to coat.
Cover and chill until ready to serve.

Ideal Apples: *Golden Delicious apples work well in salads because they are less likely
to brown. However, any crisp, subtly sweet apple that you enjoy eating out of hand
will pair well with this salad. Also try Cripps Pink or Pink Lady®, Honeycrisp, or Gala.*

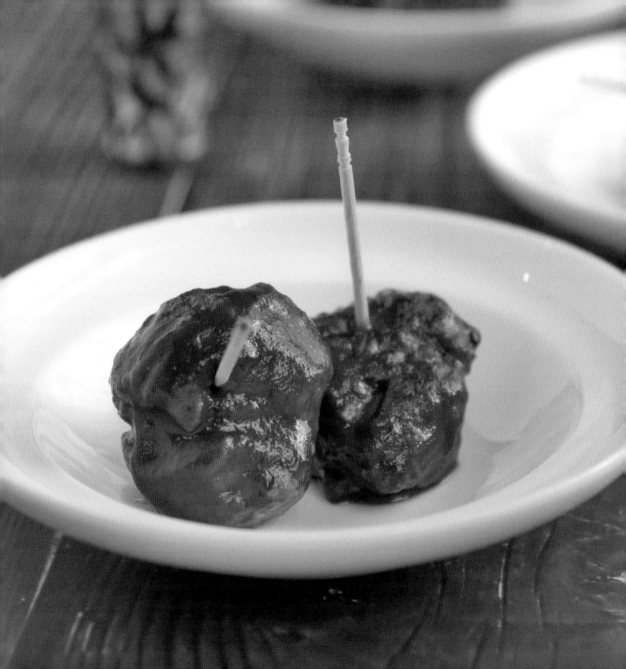

Apple Butter Meatballs

For entrée servings, top hot buttered noodles with these zesty meatballs.
For parties, make the meatballs a little smaller for one-bite servings.
Place in a warmed ceramic casserole dish with toothpicks.

makes about 2½ dozen

INGREDIENTS

½ pound lean ground beef
½ pound lean ground turkey
 or chicken
1 cup breadcrumbs or crushed
 saltine crackers
½ cup apple butter
¼ onion, finely chopped
¼ cup chopped dried apples
1 large egg
1 teaspoon salt
¼ teaspoon coarsely ground
 black pepper
Apple Butter Barbecue Sauce
 (recipe at right)

Preheat oven to 400°. Line a rimmed baking sheet with aluminum foil.

Combine beef, turkey, breadcrumbs, apple butter, onion, dried apples, egg, salt, and pepper in a large bowl. Use hands to combine mixture, if necessary.

Form mixture into 1½-inch meatballs (about 2 tablespoons each) and place on prepared baking sheet.

Bake 20 minutes or until meatballs are browned and cooked through. (May be made ahead up to this point.)

Heat Apple Butter Barbecue Sauce in a skillet. Add meatballs, tossing gently to coat.

Apple Butter Barbecue Sauce: Stir together **¾ cup apple butter**, **¼ cup ketchup**, **2 tablespoons apple cider vinegar**, **2 tablespoons honey**, **1 tablespoon hot sauce**, **2 teaspoons salt**, **2 teaspoons liquid smoke**, and **1 teaspoon yellow mustard** in a small bowl. Serve chilled, or cook over low heat until warm. Makes 1½ cups.

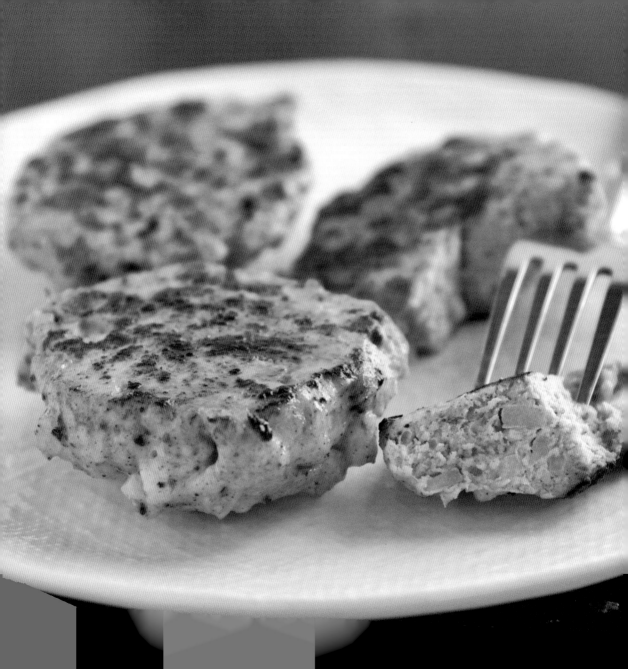

Chicken–Apple Breakfast Sausage

These sausage patties are lean and flavorful. Be sure to finely dice or chop the
apple because large pieces may cause the patty to fall apart when cooked. To bake
all together, brush the tops and bottoms of patties with olive oil and place on a
nonstick aluminum foil-lined baking sheet. Bake at 375° for 10 minutes on each side.

makes 1 dozen

INGREDIENTS

1 small apple
1 pound lean ground chicken
1 small shallot, minced
1 large egg
2 teaspoons poultry seasoning
1 teaspoon salt
¼ teaspoon coarsely ground
 black pepper
¼ teaspoon ground allspice
Olive oil

Peel apple, if desired; core and very finely chop. Place in a
large bowl. Add chicken, shallot, egg, poultry seasoning, salt,
pepper, and allspice, stirring until well blended.

Scoop sausage mixture ¼ cup at a time and form into patties.
Place on a plate or baking sheet; cover and refrigerate until
ready to prepare.

Heat a thin layer of olive oil in a nonstick skillet over medium
heat. Cook in batches for 3 to 5 minutes on each side or until
cooked through and golden brown.

*Ideal Apples: Choose an apple that remains crisp and holds
its shape when cooked, such as Fuji, Jonagold, or Pippin.*

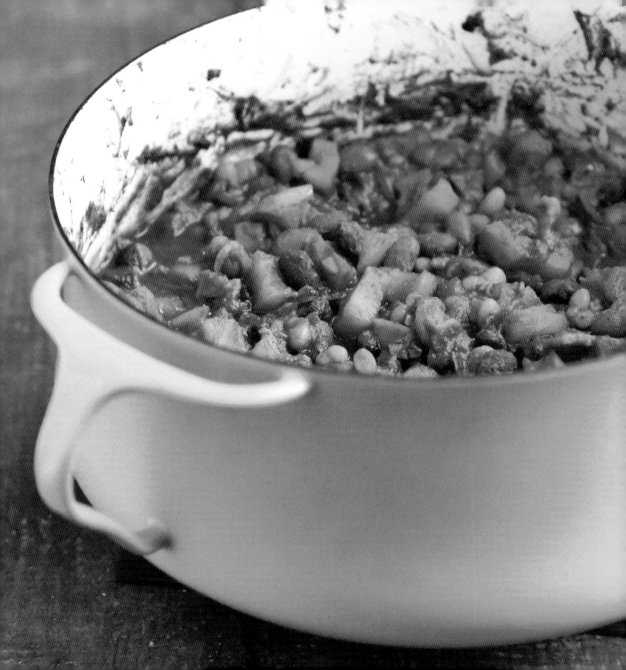

Apple Butter Baked Beans

Apple butter is thick and its texture varies, so you may need to stir in a bit more broth to get a saucy dish. Applesauce is generally thinner and will add more sweetness than flavor because there are so many zesty ingredients.

makes 12 servings

INGREDIENTS

4 slices thick-cut bacon, cut into pieces
1 onion, chopped
3 garlic cloves, minced
1 jalapeño pepper, seeded and minced
2 large apples
3 (15.5-ounce) cans beans (pinto, black, cannellini, and/or northern), rinsed and drained
1 cup purchased or Slow-Cooker Apple Butter (page 27) or purchased unsweetened applesauce or Vanilla Blush Applesauce (page 25)
½ cup vegetable broth or chicken broth
1 tablespoon chili powder
2 teaspoons ground cumin
1 tablespoon molasses
1 tablespoon hot sauce
1 teaspoon salt

Preheat oven to 375°.

Cook bacon in a 10-inch, deep-dish cast iron casserole or deep skillet over medium heat for 4 minutes or until bacon is rendered but not crispy. Remove and drain on paper towels, reserving 1 to 3 teaspoons drippings in skillet.

Add onion, garlic, and jalapeño to skillet. Cook, stirring occasionally, for 3 to 4 minutes or until onion is tender.

Peel apples, if desired. Core and chop. Add to skillet and cook 3 to 5 minutes. Stir in beans, apple butter, broth, chili powder, cumin, molasses, hot sauce, and salt.

Bake 45 minutes or until hot and bubbly.

 Ideal Apples: Use a firm baking apple with a lot of flavor, such as Granny Smith or Winesap. Softer apples can be used but may dissolve into the sauce when cooked.

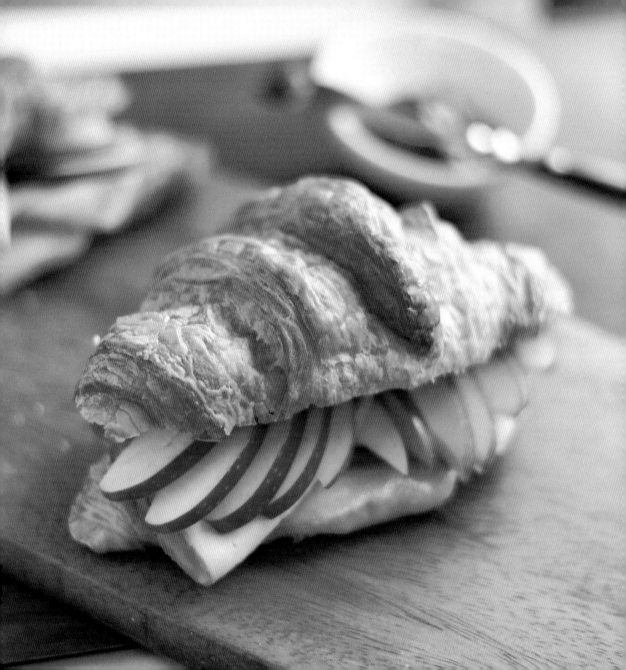

Ham-and-Apple Croissant Sandwiches

Elevate your picnic baskets beyond PB&J with this super-easy-yet-incredible combination. The best flavored ham comes from a bone-in ham you slice yourself, but you can find tasty packaged sliced ham if you avoid pressed ham products. If desired, wrap sandwiches in aluminum foil and heat in a 350° oven for 10 minutes.

makes 4 servings

INGREDIENTS

¼ cup apple butter
1 tablespoon Dijon mustard
1 large apple
4 large croissants, split
8 ounces thinly sliced smoked
 Gouda or Gruyère cheese
8 ounces thinly sliced deli ham

Combine apple butter and Dijon in a small bowl. Core and thinly slice apple.

Spread cut sides of croissants evenly with apple butter mixture. Layer cheese, ham, and apple slices on bottom pieces of bread; add tops.

Ideal Apples: Use your favorite apple in this simple yet flavorful sandwich. Try Granny Smith if you like tart apples or Gala if you like them sweet.

Apple-Sausage-Cheddar Cornbread

I started making a version of this cornbread for a Southern-style dressing, but it's too tasty to save for holiday meals. The recipe morphed into a skillet bread that is hearty enough to eat as an entrée, especially if served with a simple salad. Leftovers are yummy, and I try to save some for a quick portable breakfast.

makes 8 servings

INGREDIENTS

1 pound bulk pork or
 turkey sausage
2 apples
1½ cups (6 ounces) shredded
 cheddar cheese
1 cup yellow cornmeal
1 cup all-purpose flour
1 tablespoon baking powder
½ teaspoon ground sage
½ teaspoon salt
1¼ cups buttermilk
1 large egg
4 tablespoons butter
Chopped fresh parsley or
 green onions

Preheat oven to 425°.

Cook sausage in a 10-inch cast iron skillet over medium-high heat until browned and crumbly. Drain and transfer sausage to a large bowl; wipe skillet with a paper towel.

Core and finely chop apples. Stir apples and cheese into sausage.

In a separate bowl, combine cornmeal, flour, baking powder, sage, and salt. Whisk buttermilk and egg together in a small bowl or measuring cup.

Place butter in skillet and place skillet in oven until butter melts.

While butter melts, stir cornmeal mixture into sausage mixture. Add buttermilk mixture, stirring until well blended.

Remove skillet from oven and spoon in sausage mixture. Bake 30 minutes or until cooked through and light golden brown. Sprinkle with parsley or green onions.

 Ideal Apples: Select a variety that holds up during baking so the apple bits will be noticeable. Granny Smith, Honeycrisp, Golden Delicious, Rome, and Fuji are popular options. Make it easy and keep the peel on.

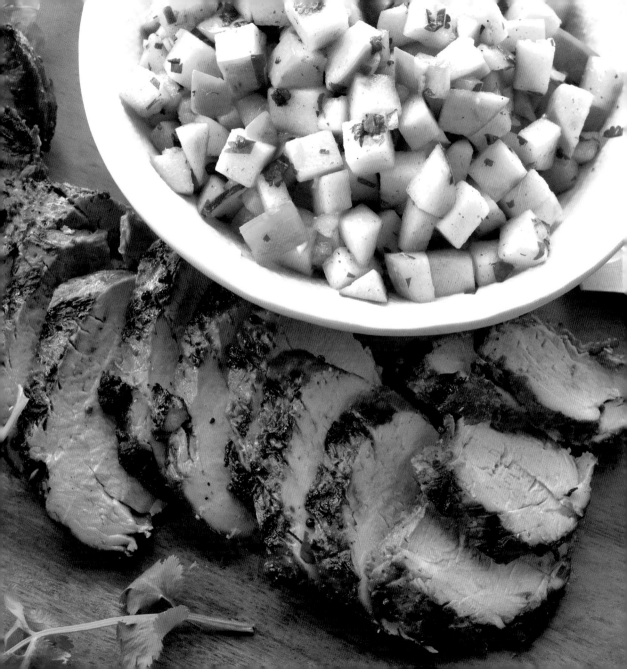

Marinated Pork Tenderloin with Apple Salsa

Marinate the pork at least 1 hour; for best flavor, combine the ingredients in the morning or the night before cooking. The Apple Salsa should be prepared closer to dinner so the flavor remains fresh. Because pork tenderloins often come two to a package, this marinade is generous enough for both.

makes 6 servings

INGREDIENTS

- ¾ cup frozen and thawed apple juice concentrate
- ¼ cup soy sauce
- 2 tablespoons olive oil
- 2 tablespoons whole-grain mustard
- ½ teaspoon coarsely ground black pepper
- 2 (1¼-pound) pork tenderloins
- Apple Salsa (recipe at right)

Combine apple juice concentrate, soy sauce, olive oil, mustard, and black pepper in a large zip-top plastic storage bag.

Trim excess fat and silver skin from tenderloins. Place pork in bag; seal and refrigerate 1 hour or up to 1 day. Turn bag occasionally.

Prepare grill or preheat oven to 375°.

Remove pork from marinade. Place pork on greased grill rack and grill (or place on an aluminum foil-lined baking sheet and bake for 25 minutes) until a meat thermometer registers 160°. Let meat stand 10 minutes before slicing. Serve with Apple Salsa.

Apple Salsa: Core **2 large apples** and finely dice; place in a large bowl. Add **1 seeded and minced jalapeño pepper**, **1 large garlic clove**, **2 tablespoons minced red onion**, **2 tablespoons chopped fresh mint**, **1 teaspoon lime zest**, **2 tablespoons fresh lime juice**, **1 tablespoon honey** or **light brown sugar**, and **¼ teaspoon salt**, stirring until well blended. Cover and chill until ready to serve. Makes 2 cups.

Ideal Apples: A crisp and crunchy apple like Honeycrisp, Gala, or Fuji makes a sweet and juicy salsa side.

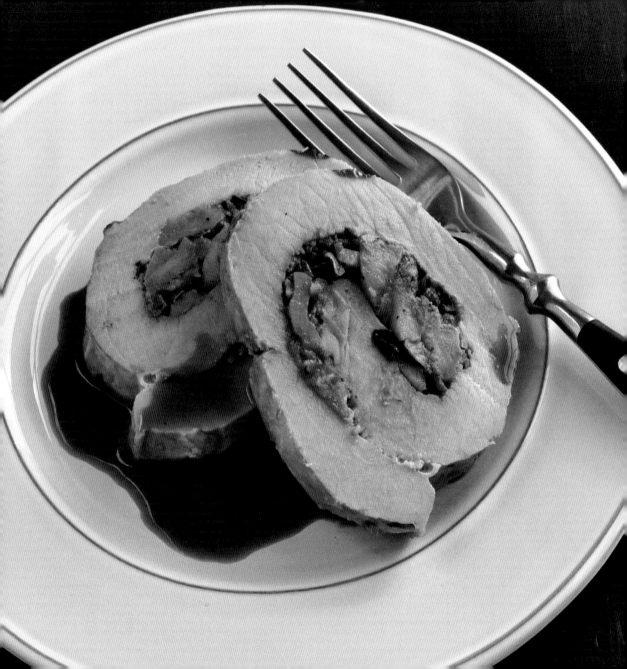

Apple-Stuffed Pork Loin

When you butterfly a pork loin, you are cutting the meat so it opens in three sections like business letters are folded. Ask the butcher at a full-service meat department for help.

makes 8 servings

INGREDIENTS

1 (3½- to 4-pound) boneless
 pork loin roast
2 tablespoons butter
3 apples, peeled, halved, and
 thinly sliced
⅓ cup chopped pecans
3 tablespoons molasses, divided
2 teaspoons thyme, divided
½ teaspoon salt
¼ teaspoon coarsely ground
 black pepper
¾ cup water or broth
2 tablespoons brown sugar
2 tablespoons apple
 cider vinegar
2 tablespoons honey
¼ cup whipping cream

Ideal Apples: Use a firm baking apple that won't fall apart when cooked. Good choices are Granny Smith, Jonagold, and Northern Spy.

Preheat oven to 375°.

Place pork on a cutting board and trim away excess fat and silver skin. Make a horizontal slice ½ inch from the bottom down the length of the roast and toward the other side, stopping ½ inch from edge. Open roast and make a horizontal cut through the thickest side, starting at the center, stopping again about ½ inch from edge. Unfold to create a square; pound to an even thickness with a meat mallet. Set aside.

Melt butter in a skillet over medium heat. Add apples and cook 8 minutes or until tender. Stir in pecans, 1 tablespoon molasses, 1 teaspoon thyme, salt, and pepper. Spoon over pork, leaving a ½-inch border. Roll up roast; tie with string. Place, seam side down, in a greased shallow roasting pan.

Combine broth, brown sugar, vinegar, honey, remaining 2 tablespoons molasses, and remaining 1 teaspoon thyme in a bowl. Pour over pork. Bake for 45 to 60 minutes or until a meat thermometer inserted into thickest portion registers 160°. Baste pork with liquid periodically. Remove pork from pan and let rest, covered with aluminum foil, on a cutting board for 15 minutes. Transfer liquid to a skillet. Stir in cream. Bring to a boil, reduce heat, and simmer 5 to 10 minutes or until slightly thickened. Serve sauce over sliced pork.

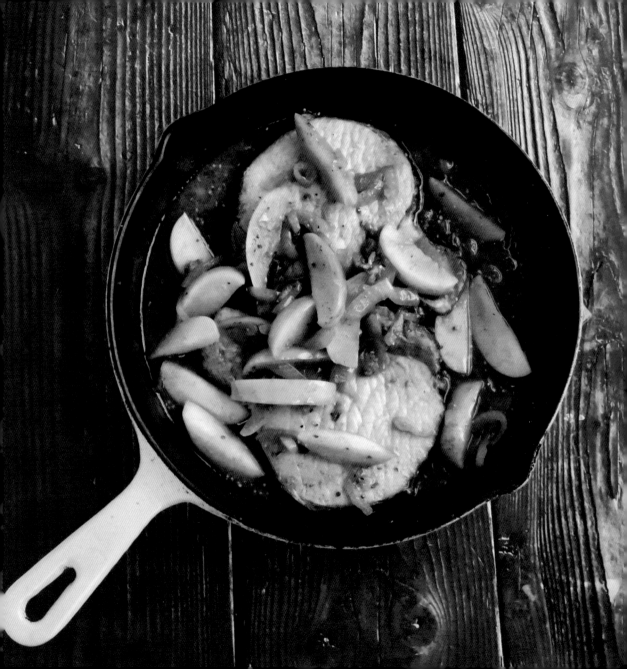

Smoked Pork Chops and Apple Skillet

Smoked pork chops make a great shortcut to a quick-and-easy dinner. If you want to use raw pork chops, bone-in or boneless, sauté them in butter or olive oil for 3 to 5 minutes on each side. Remove from pan and proceed with recipe.

makes 2 servings

INGREDIENTS

2 tablespoons butter
1 sweet or red onion, halved and sliced
½ teaspoon ground sage
¼ teaspoon salt
¼ teaspoon coarsely ground black pepper
2 medium-size apples
½ cup chicken broth or stock
2 teaspoons stone ground Dijon mustard
1 (15-ounce) package fully cooked, bone-in smoked pork chops

Melt butter in a large skillet over medium-high heat. Add onion, sage, salt, and pepper. Cook, stirring frequently, for 5 minutes or until onion is tender.

Core apples and thickly slice. Whisk together broth and mustard in a small bowl.

Arrange smoked pork chops and apples in skillet. Pour broth mixture over pork and apples. Bring mixture to a boil. Cover, reduce heat to medium-low and simmer 8 to 10 minutes or until pork is heated through and apples are tender.

Ideal Apples: Stick with a firm textured apple that won't fall apart when sautéed: Granny Smith, Fuji, or Honeycrisp.

Index

A

Albemarie Pippin apples, 21
Almond-Apple Crisp, 98–99
Ambrosia apples, 16
Apple Baklava, 46–47
Apple Blondies, 44–45
Apple Bundt Cake with Maple Glaze, 84–85
apple butter
 baked beans, 118–119
 best apples for, 13
 -bourbon sauce, 32–33
 slow-cooker, 26–27
Apple Butter Baked Beans, 118–119
Apple Butter Meatballs, 114–115
Apple Butter-Bourbon Sauce, 32–33
Apple Cheddar Biscuits, 60–61
Apple Custard Pie, 70–71
Apple Noodle Kugel, 96–97
Apple Pie Cookie Cups, 40–41
Apple Puff Roses, 48–49
apple salsa, 125
Apple Spice Cake with Butterscotch Drizzle, 82–83
Apple Streusel Cheesecake, 88–89
Apple Tabbouleh Salad, 112–113
Apple-Cheddar Beer Soup, 106–107
Apple-Cinnamon Quick Bread, 58–59
Apple-Cinnamon Scones, 56–57
Apple-Cranberry Jam, 30–31
Apple-Cranberry Lattice Pie, 74–75
apples
 about, 10–15
 best uses for, 12–13
 browning, 14–15
 buying, 11–12
 nutrition of, 15
 ripening, 14
 storage of, 13–14
 varieties of, 16–21
applesauce
 best apples for, 13
 -soy vinaigrette, 109
 vanilla blush, 24–25
Apple-Sausage-Cheddar Cornbread, 122–123
Appleseed, Johnny (John Chapman), 10
Apple-Stuffed Pork Loin, 126–127

B

baked beans, apple butter, 118–119
Baked Apple Clafouti, 90–91
baklava, apple, 46–47
bars
 apple blondies, 44–45
 nutty apple, 42–43
best uses for apples, 12–13
beverages. See jams, sauces, and beverages
biscuits, apple cheddar, 60–61
Braeburn apples, 16
bread
 apple-cinnamon quick, 58–59
 apple-sausage-cheddar cornbread, 122–123

breads, *See* cookies, breads, and small bites
Broccoli-Apple Salad, 110–111
browning apples, 14–15
Butterscotch Apple Cupcakes, 86–87
butterscotch drizzle, 83
butterscotch frosting, 87
buying apples, 11–12

C
cake
 apple bundt, 84–85
 apple spice, 82–83
Cameo apples, 16
Caramel Apples, 94–95
carpels, 11
Chapman, John (Johnny Appleseed), 10
Cheese-Apple Danish, 80–81
cheesecake, apple streusel, 88–89
Chicken, Apple, and Napa Cabbage Salad,
 108–109
Chicken-Apple Breakfast Sausage, 116–117
cider
 best apples for, 13
 hot mulled, 34–35
clafouti, baked apple, 90–91
climacteric foods, 14
cookies
 See also cookies, breads, and small bites
 apple pie cookie cups, 40–41
 toffee-apple oatmeal, 38–39
cookies, breads, and small bites, 36–61
 Apple Baklava, 46–47
 Apple Blondies, 44–45

Apple Cheddar Biscuits, 60–61
Apple Pie Cookie Cups, 40–41
Apple Puff Roses, 48–49
Apple-Cinnamon Quick Bread, 58–59
Apple-Cinnamon Scones, 56–57
Easy Apple Hand Pies, 50–51
Herbed Apple Mini Muffins, 54–55
Nutty Apple Bars, 42–43
Toffee-Apple Oatmeal Cookies, 38–39
Whole-Grain Apple Muffins, 52–53
Corland apples, 17
Cosmic Crisp apples, 17
cream cheese frosting, 83
Cripps Pink apples, 17
crisp, almond-apple, 98–99
Crispin apples, 17
cupcakes, butterscotch apple, 87–88

D
Danish, cheese-apple, 80–81
desserts. See sweets and desserts
dumplings, Fruit-Stuffed apple, 92–93
Dutch Apple Crumble Pie, 72–73

E
Easy Apple Hand Pies, 50–51
Easy Double Crust Apple Pie, 66–67
Empire apples, 17
Envy apples, 17

F
Fruit-Stuffed Apple Dumplings, 92–93
Fuji apples, 18

G

Gala apples, 18
Ginger Gold apples, 18
Golden Delicious apples, 18
Granny Smith apples, 18
Gravenstein apples, 18

H

Ham-and-Apple Croissant Sandwiches, 120–121
Herbed Apple Mini Muffins, 54–55
Honeycrisp apples, 19
Hot Mulled Cider, 34–35

I

Idared apples, 19

J

jam, apple-cranberry, 30–31
jams, sauces, and beverages, 22–35
 Apple Butter-Bourbon Sauce, 32–33
 Apple-Cranberry Jam, 30–31
 Hot Mulled Cider, 34–35
 Slow-Cooker Apple Butter, 26–27
 Spiced Apple Jelly Sauce, 28–29
 Vanilla Blush Applesauce, 24–25
Jazz apples, 19
Jonagold apples, 19
Jonathan apples, 19

K

Kanz apples, 19
Kiku apples, 20
kugel, apple noodle, 96–97

L

Lady Alice apples, 20
lenticels, 11–12

M

Macoun apples, 20
maple glaze, 85
Marinated Pork Tenderloin with Apple Salsa, 124–125
McIntosh apples, 20
meatballs, apple butter, 114–115
Mincemeat Pie, 76–77
muffins
 herbed apple mini, 54–55
 whole-grain apple, 52–53
Mutsu apples, 17

N

Newtown apples, 21
Northern Spy apples, 20
nutrition of apples, 15
Nutty Apple Bars, 42–43

O

Open-Faced Apple Pie with Salted Pecan Crumble, 64–65

P

pastry dough, spiced, 93
pectin, 15
piecrust dough, 65
pies
 See also sweets and desserts
 apple custard, 70–71

apple-cranberry lattice, 74–75
best apples for, 12
Dutch apple crumble, 72–73
easy apple hand, 50–51
easy double crust apple, 66–67
mincemeat, 76–77
open-faced apple, 64–65
upside-down apple-pecan, 68–69
Piñata apples, 20
Pink Lady apples, 17
Pippin apples, 21
pork
 loin, Apple-Stuffed, 126–127
 smoked chops and apple skillet, 128–129
 tenderloin with apple salsa, marinated,
 124–125
pudding, sweet apple rice, 100–101

R
Red Delicious apples, 21
ripening apples, 14
Roasted Apple-Parsnip Soup, 104–105
Rome or Rome Beauty apples, 21

S
salad
 See also soups, salads, and savories
 apple tabbouleh, 112–113
 broccoli-apple, 110–111
 chicken, apple, and Napa cabbage, 108–109
sandwiches, ham-and-apple croissant, 120–121
sauces
 See also jams, sauces, and beverages
 apple butter-bourbon, 32–33
 spiced apple jelly, 28–29

sausage, chicken-apple breakfast, 116–117
savories. see soups, salads, and savories
scones, apple-cinnamon, 56–57
Simple Apple Tart, 78–79
Slow-Cooker Apple Butter, 26–27
small bites. See cookies, breads, and small bites
Smoked Pork Chops and Apple Skillet,
 128–129
soup
 See also soups, salads, and savories
 apple-cheddar beer, 106–107
 roasted apple-parsnip, 104–105
soups, salads, and savories, 102–129
 Apple Butter Baked Beans, 118–119
 Apple Butter Meatballs, 114–115
 Apple Tabbouleh Salad, 112–113
 Apple-Cheddar Beer Soup, 106–107
 Apple-Sausage-Cheddar Cornbread, 122–123
 Apple-Stuffed Pork Loin, 126–127
 Broccoli-Apple Salad, 110–111
 Chicken, Apple, and Napa Cabbage Salad,
 108–109
 Chicken-Apple Breakfast Sausage, 116–117
 Ham-and-Apple Croissant Sandwiches,
 120–121
 Marinated Pork Tenderloin with Apple Salsa,
 124–125
 Roasted Apple-Parsnip Soup, 104–105
 Smoked Pork Chops and Apple Skillet,
 128–129
Spiced Apple Jelly Sauce, 28–29
spiced honey syrup, 47
storage of apples, 13–14
SugarBee apples, 21

Sweet Apple Rice Pudding, 100–101
Sweetango apples, 21
sweets and desserts, 62–101
 Almond-Apple Crisp, 98–99
 Apple Bundt Cake with Maple Glaze, 84–85
 Apple Custard Pie, 70–71
 Apple Noodle Kugel, 96–97
 Apple Spice Cake with Butterscotch Drizzle,
 82–83
 Apple Streusel Cheesecake, 88–89
 Apple-Cranberry Lattice Pie, 74–75
 Baked Apple Clafouti, 90–91
 Butterscotch Apple Cupcakes, 86–87
 Caramel Apples, 94–95
 Cheese-Apple Danish, 80–81
 Dutch Apple Crumble Pie, 72–73
 Easy Double Crust Apple Pie, 66–67
 Fruit-Stuffed Apple Dumplings, 92–93
 Mincemeat Pie, 76–77
 Open-Faced Apple Pie with Salted Pecan
 Crumble, 64–65
 Simple Apple Tart, 78–79
 Sweet Apple Rice Pudding, 100–101
 Upside-down Apple-Pecan Pie, 68–69

T
tarts, simple apple, 78–79
Toffee-Apple Oatmeal Cookies, 38–39

U
Upside-down Apple-Pecan Pie, 68–69

V
Vanilla Blush Applesauce, 24–25

W
Whole-Grain Apple Muffins, 52–53
Winesap apples, 21

EXPLORE THE ENTIRE SERIES OF
Nature's Favorite Foods Cookbooks!

blueberries
50 TRIED & TRUE RECIPES
Julia Rutland

978-1-59193-847-7 • $16.95

maple syrup
40 TRIED & TRUE RECIPES
Corrine Kozlak
photography by Kevin Scott Ramos

978-1-59193-931-3 • $16.95

rhubarb
50 TRIED & TRUE RECIPES
Corrine Kozlak
photography by Kevin Scott Ramos

978-1-59193-828-6 • $16.95

squash
50 TRIED & TRUE RECIPES
Julia Rutland

978-1-59193-909-2 • $16.95

About the Author

Julia Rutland is a Washington, D.C.-area food writer, recipe developer, and master gardener whose work appears regularly in publications and websites such as *Southern Living* magazine, Weight Watchers books, *Bottom Line Personal* magazine, and more. She is the author of *Discover Dinnertime, The Campfire Foodie Cookbook, On a Stick, Blueberries, Squash,* and *Foil Pack Dinners Cookbook.*

Julia lives in the D.C. wine country town of Hillsboro, Virginia, with her husband, two daughters, and a bevy of furred and feathered pets.